P9-CQZ-622

Marilyn G. Stewart

Thinking through Aesthetics

Davis Publications, Inc., Worcester, Massachusetts

ART EDUCATION IN PRACTICE SERIES

Marilyn G. Stewart

Editor

Marilyn G. Stewart

Thinking through Aesthetics

Series Preface

Follow an art teacher around for a day—and then stand amazed. At any given moment, the art teacher has a ready knowledge of materials available for making and responding to art; lesson plans with objectives for student learning; resources for extending art learning to other subjects; and the capabilities, interests, and needs of the students in the artroom. Working with a schedule that sometimes requires shifting several times a day from working with students in preschool to those in elementary, middle, and high school, the art teacher decides what to teach, how to teach it, whether students have learned it, and what to do next. The need for rapid decision making in the artroom is relentless.

The demands continue after school as the art teacher engages in assessment of student learning, curriculum planning, organization of materials, and a wide range of activities within the school community. Although most teachers want to be aware of and to integrate into their teaching new findings and developments within their field, they are pressed to find the time for routine, extensive reading of the literature.

Art Education in Practice provides the art teacher, museum educator, student, scholar, and layperson involved in art education with an overview of significant topics in art education theory and practice. The series is designed to meet the needs of art educators who want to know the issues within, the rationales provided for, and the practical implications of accepting curricular proposals presented from a variety of scholarly and political perspectives.

The emphasis of the series is on informed practice. Each text focuses on a topic that has received considerable attention in art education literature and advocacy statements, but one that has not always been accompanied by clear, concise, and accessible recommendations for the classroom. As new issues arise, books will be added to the series. The goal of the series is to complement the professional libraries of practitioners in the field of art education and, in turn, enhance the art-related lives of their students.

Editor's Introduction

In an inquiry-based approach to the teaching of art, questions are used to pull apart the issues surrounding art and to fit them into new patterns. Students become active seekers rather than passive absorbers. Questions emphasizing the "why" more than the "what" or how" lead somewhere rather than simply recounting what is already believed to be true.

Student interaction, with works of art and with each other, is an important element of an inquiry approach to art education. Teachers design art experiences to facilitate this interaction through both large and small group discussion and individual study, research, or investigation.

The security of designing good inquiry-based art experiences lies in knowing how to inquire rather than being an expert in any specific body of content. To achieve this security, we must know the process of inquiring, be well organized, be adept at using the skills of inquiry, and have a conceptual framework that leads us to ask a wide variety of useful questions.

This book is a practical guide to help teachers feel secure with the organization and structure necessary for successful inquiry teaching. Teachers interested in improving their questioning skills as well as their ability to identify significant artworld issues will find many classroom tested models and suggestions to assist them. Marilyn Stewart, well known for her work in philosophical inquiry and discipline-based art education, provides many examples of well organized teaching. She gives examples based on rational inquiry and shows how the inquiry process can be used in the classroom and art studio to help students realize they can think clearly about aesthetics.

For teachers who are uncertain about what it means to teach aesthetics, Stewart provides both a solid theoretical foundation and a strong conceptual framework in easy to understand terms. She offers many examples of how the teaching of aesthetics can be approached in elementary, middle, and secondary schools. Stewart cuts through vague notions about aesthetics as perception and "touchy-feely" responding, focusing on sound philosophical inquiry coupled with engaging aesthetic issues in a variety of realistic classroom settings. Her suggestions for sparking students' curiosity and sustaining their wonder about art and what it means to be human have implications across the curriculum and for learning in general.

As the title suggests, this book is more than just another book about aesthetics. It is also about thinking. More specifically, it is about the processes of clear thinking, sound reasoning, and good argument. In this sense, an appropriate subtitle might be "teaching students to think clearly through discussions about art." For the classroom teacher, aesthetics becomes a vehicle for teaching critical thinking in an interdisciplinary program.

An equally appropriate subtitle also might be "helping students to think about art and the complex nature of aesthetic experience." Through classroom scenarios, Stewart carefully illustrates what it means to teach aesthetics as one of the discipline components of a balanced and sequential art program. For the art teacher, philosophical inquiry becomes an essential process for understanding art and its relationship to students' lives.

Eldon Katter

For Ben and Katie Stewart

Publisher: Wyatt Wade
Editorial Director: Helen Ronan
Production Editor: Nancy Wood Bedau
Manufacturing Coordinator: Steven Vogelsang
Assistant Production Editor: Carol Harley
Editorial Assistance: Robin Banas
Copyeditor: Lynn Simon
Design: Jeannet Leendertse

Library of Congress Catalog Card Number: 97-075082
ISBN: 87192-362-9
ISBN: 978-0-87192-362-2
10 9 8 7 6 5 4
Printed in the United States of America

Table of Contents

Acknowledgments

I wish to thank my colleagues in art education: Eldon Katter, a consistent source of inspiration and encouragement, who read the draft, wrote an introduction, and gave me the title for this book; John White, my "attic mate" in Boxwood House, the home of Art Education at Kutztown University, for the many conversations we've had about art and teaching; Tom Schantz, for his friendship, unwavering support, and the steady stream of philosophical issues—clipped and sent through campus mail; Mary Erickson, for suggesting to me long ago that I get out of the clouds and start working with the teachers in the field; and Dwaine Greer, for encouraging me early on to try out new ways of thinking about aesthetics and for giving me so many opportunities to do so with teachers.

A special thanks to Georgia Chamley and Morris Perinchief, for helping me identify philosophical problems posed in art history. Thanks also to the many teachers around the country who, in institutes and seminars have helped me clarify my thinking and who have sent me examples of student writing. In particular, I wish to thank art teachers Suzy Becker, Jennifer Blazek, Caren Cornman, Jeffrey Dietrich, Brenda Jones, and Karen Shriner who have inspired me with their fine work and who have been kind enough to share their ideas and student work with me, often coming to my rescue at the last minute. I wish to thank Heather Heilman, Melinda Gavitt, and Sam Fritch who, in the past as my student assistants and now as my friends and colleagues, have helped keep me focused and organized.

Thanks to the fine people at Davis Publications: Wyatt Wade, for presenting me with the idea of editing a series of books for teachers and for his patience as he waited to see *Art Education in Practice* and this book in print; Carol Harley and Robin Banas, for their good-humored attention to detail; Lynn Simon, for her careful and insightful copyediting; and Jeannet Leendertse, for her dynamic and pleasing design. My editor and friend, Helen Ronan, has guided me through the process of writing this book and editing the *Art Education in Practice* series. I cannot thank her enough for her patience and for tolerating my anxieties and joys during the writing and editing process.

Finally, I wish to thank Dr. Deborah Sieger for the early morning cups of coffee, for taking care of the animals, tolerating my outbursts, and for always focusing on my strengths with unconditional love.

Marilyn G. Stewart

Introduction

Upon leaving a retrospective exhibition of twentieth-century artist Cy Twombly, held at the Museum of Modern Art, in New York City, I overheard the following conversation between two people who were also leaving the show.

She: *Well, it's not that I didn't like the art; it's just that I can't see what's so great about it. Here it is in one of the biggest and most important museums in the country. What does it have that other artworks don't have? It seems so simple. Why is it here?*

He: *I know; it doesn't look like it took much talent to create it. Maybe it's because he did it first. Even though it looks like just anybody could do it, nobody else did do it. It's unique and original.*

She: *So, does that make it good? Just because he did something nobody else did? Is that what makes art important enough to be shown at the Museum of Modern Art? What makes something good art?*

He: *Uh, . . . I dunno. Let's go get some lunch.*

As I watched them walk toward the museum restaurant, I smiled a smile of recognition and amusement. The exchange was similar to many

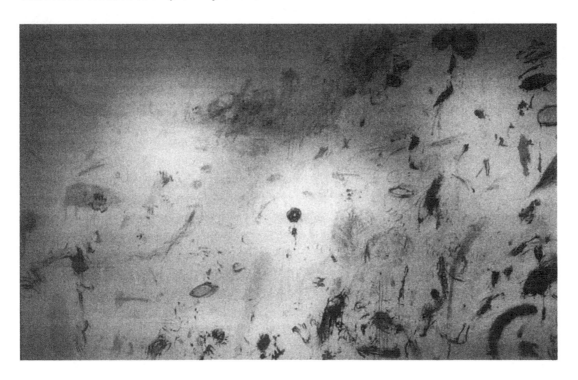

Cy Twombly, Triumph of Galatea, 1961 (Rome).
Oil paint, oil-based house paint, wax crayon, lead pencil on canvas, 115 7/8 x 190 3/8" (294 x 483 cm).
Courtesy of the Menil Collection, Houston and Cy Twombly Gallery, Houston, gift of the artist.
Photo: Paul Hester, Houston.

I have heard before—in galleries and museums and in the classes I teach. I was amused by the abrupt way in which the conversation ended. It was clear that the questions raised were complicated enough to provide a focus for several hours of discussion. It also was clear, however, that these two museum visitors were soon going to move on to other topics.

In galleries and museums throughout the city, as visitors wondered encountered artworks, I suspect that similar comments and questions were being put forward. In some cases, those visitors simply moved along to the next gallery or, perhaps, to their next meal. But I suspect that some visitors continued to question the nature and significance of what they had perceived.

In these extended conversations, the participants may have listened to the views of one another about art—what it is, what it is for, why some works seem to be better than others, and why some works and not others are included in one-person museum exhibitions. As a result of these discussions, the participants may have changed their minds a bit. Perhaps they would approach the next museum visit differently. People who take part in such discussions tend to ask *new* questions and approach the next artworks they encounter with insights gleaned from previous conversations.

People do wonder about art. They ask one another questions; they put forward ideas they have considered themselves or heard from others. Sometimes, people have strong beliefs and adamant questions about art. On the campus where I teach, we have a history of wondering, resentment, and even anger when sculptures are installed on the grounds. A large concrete and stone sculpture was recently installed outside one of the science buildings on campus, and its installation has been met with a flurry of angry comments about it and its placement. One professor is angry that his favorite view of the

campus is obstructed. Another is angry that the placement interferes with the functioning of his weather-monitoring equipment. Some members of the university community have written letters to the editor of the school paper demanding that tuition dollars ought to be put to better use, that what appears to be a construction site ought not be called art. Some have maintained that even they could do better if given the chance. Others have defended the work, claiming that art is supposed to cause people to think, that the sculpture is a welcome addition to an otherwise uninteresting campus. Some advocates have said that the materials used are beautiful. Others have claimed that the form of the sculpture is complex and dynamic.

Sometimes, people resign themselves to the belief that questions surrounding debates such as that on our campus are merely matters of opinion. There is a widespread assumption that when attempting to judge the merits of artworks, one person's opinion is as good as another's; these are matters of taste, and there is no disputing matters of taste. The view presented in this book is that in matters such as these and in other important areas of discussion about art, there is much to be gained by spending some time exploring our own views and those of others. The informal and formal discussions about the sculpture are important ways for individuals within a community to clarify their beliefs, learn from one another, and, perhaps, change their minds.

The debate about the sculpture on my campus is similar to debates on other campuses and in communities when sculptures are placed in prominent places or when certain kinds of artworks are made available to the public. From such debates, it is clear that people have beliefs about art that can be explored, clarified, and sometimes changed. From my experiences as a mother and a former art teacher, it is clear

Others on Twombly's Work

In a *60 Minutes* segment, Morley Safer described the work of Cy Twombly as "a canvas of scrawls done with the wrong end of a paintbrush."[1]

Artist and critic Peter Plagens said, "For all its look of chance, Twombly's work is fearlessly composed and passionately colored. The best of his paintings—such as *The Triumph of Galatea* (1961)—are like vast desert dunes with scattered flowers growing in them. But the dunes are cut into perfect rectangles and the flower seeds have been delicately sown by dreams."[2]

Arthur Danto, philosopher and art critic, said of Twombly's work, "Scribbles, scrapings, rubbings, uncoordinated on often-vast expanses of space . . . There is an almost Taoist political metaphor here for those who seek such things: Out of the elements of human expression at its most basic, work of the greatest beauty is made. When you visit the show, take it all in rather quickly, then go back to bear down on one or two paintings at most. Buy the catalogue, do some reading, and then bear down some more. After that, try another painting or two."[3]

that elementary- and secondary-school students also have beliefs about art.

When students voice their views about art and other art-related matters and when members of a community respond to art exhibitions and campus sculptures, they do so in an effort to contemplate and understand their world—to conceptualize and categorize their experiences. This seems to be a common activity with human beings. We need only to consider how humans over time and throughout the world have created imagery, narratives, and rituals in an attempt to explain their relationships to the natural world and one another to conclude that they tend to wonder at the world before them. In an effort to understand natural and social phenomena, humans have presented complex and varied accounts of the things they deem important in understanding their world.

Education philosopher Thomas Green proposes that wonder is rooted in our knowledge that things need *not* be as they are.[4] Green suggests that it is when we wonder at the ordinary—recognizing that while ordinary things can be *depended* on to occur, they need not always occur—we sustain our wonder and interest. To make his point, he uses the example of our wonder at the simple act of planting an apple seed and expecting it to turn into an apple tree. He suggests that this apparently simple and predictable process is cause for sustained wonder. Human beings have paused over time to wonder at, explore, and offer explanations for seemingly ordinary phenomena—things we most often take for granted. I believe that those who take the time to consider sculpture on campus or artworks they have seen are exercising a basic inclination to wonder about and organize their experiences with their world.

We humans also seem to have the need to create order out of chaos. In wondering at and asking questions about ordinary things and events, we have placed conceptual limits on and have made distinctions about these phenomena. At times, the interest has not been so much related to particular events or phenomena, but rather to human experience or the world *in general*. Throughout history and in different cultures, individuals have contemplated general questions about such things as human nature; about the place of our experienced world in the order of the universe; and about the nature of truth, goodness, and beauty. Centuries ago, Plato, Aristotle, Confucius, and other thinkers recorded their views and offered extended and organized explanations about matters that have importance to all humans. We still read and react to their views today. Throughout history, others have devoted major portions of their lives to involvement in an ongoing dialogue about these matters. In the Western world, these people are called philosophers, and the activity in which they engage is philosophical inquiry.

What is important to note is that as philosophers engage in dialogues, they represent the rest of us in the process. Their questions are important to us because they are also our questions. These philosophers, however, take more time, and probably more sustained care, to address the questions. This impulse to raise significant questions about our experience, to create order out of chaos, to conceptualize and categorize, and to offer possible explanations is as natural today as it has been over time. As adults, as teachers, and as students, we often wonder at the ordinary. Sometimes we take the opportunity to go further, to make conceptual distinctions and offer theoretical perspectives. We participate in philosophical inquiry more than we probably realize.

The purpose of this book is to provide teachers with ways to help students engage in these important dialogues. The two visitors to the Museum of Modern Art left the show with important questions about what makes an artwork significant. They began a discussion in which they proposed possible answers to their questions, but they soon dismissed the whole matter. In noting their conversation, I was struck by the possibility that they did not have the knowledge and skills required to take the discussion further. I believe that in artrooms around the country, as students wonder about art, they too fail to move from the point of raising questions to involvement in rich, layered discussions through which they might clarify their own beliefs, hear and learn from others, and perhaps even alter their own views.

For many reasons, we teachers have been hesitant to provide students with opportunities for philosophical inquiry. One reason for this is the persistent view that philosophical discussions almost always involve what is thought of as merely opinion. In addition, teachers have not always been prepared, through preservice professional education, to deal

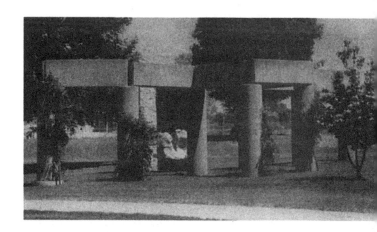

Tom Sternal, Pavillion, *1993. Reinforced concrete, marble, sandstone, wisteria and virginia creeper vines, 12.5 x 30' (3.8 x 9.1 m). Photo: Katherine Stewart.*

with philosophical issues that might arise. We have lacked guidelines for designing strategies for including philosophical inquiry as a regular part of art instruction. When asked to develop lesson outcomes or objectives, we have not had models of philosophical inquiry to guide us.

This book is an attempt to provide teachers with such models. In addition to providing a rationale for the inclusion of philosophical inquiry in the art program, it provides information about theories of art, suggestions for planning for philosophical inquiry, sample program and lesson outcomes or objectives, and examples of lesson plans and other resources useful for the teacher who wishes to add philosophical inquiry to the curriculum.

Chapter 1 introduces aesthetics as an area of philosophical inquiry and shows its connections to the interests and abilities of children and, ultimately, the concepts, skills, and attitudes promoted through the art curriculum.

Chapter 2 provides a brief overview of traditional perspectives in Western aesthetics and introduces ways to identify philosophical questions. It offers a sense of the questions and answers that have been addressed over the years, showing the connection between these views and those of students considering philosophical issues as they make and respond to art.

Chapter 3 introduces some guidelines for engaging students in philosophical dialogues.

The focus of Chapters 4–7 is on practice. Readers will find suggestions for teaching concepts and skills associated with philosophical inquiry. Many of the suggested strategies are from teachers who have gone beyond simply allowing questions and issues to arise, who have planned for such questions and issues, and who have designed lessons and units around them. Specific learning outcomes are also suggested.

When children try to organize their apparently unconnected art experiences into a coherent framework, they learn that focused attention to seemingly minor issues can help them clarify their own assumptions and beliefs. As they learn to listen to and carefully consider the views of others, they may be willing to approach the world less dogmatically. As they experience satisfaction in owning their ideas, children may be disposed to routinely question and give concentrated attention to their art-related lives.

I'd like to think that this book will prove useful for teachers and that as a result of incorporating some of the ideas suggested into their programs, their students will experience the satisfaction and rewards of philosophical inquiry. I'd also like to think that when their students next encounter an exhibition of artwork that triggers philosophical questioning, their conversations with friends will not come to an abrupt end by going off to lunch. I envision, instead, an exchange that sets the agenda for lunch and for a dialogue that continues throughout their friendship and over whatever meals they share.

Notes

1 Michael A. Lipton and Susan Carswell, "Rogues' Gallery," *People*, 11 November 1993, p. 67, referring to a September 19, 1993 *60 Minutes* segment.
2 "Gods Are in the Details," *Newsweek*, 10 October 1994, 76
3 "Cy Twombly," *The Nation*, 31 October 1994, 507.
4 Thomas F. Green, *The Activities of Teaching* (New York: McGraw-Hill, Inc., 1971).

Chapter

Philosophy, Aesthetics, and Children

We raise philosophical questions more than we probably realize. Singular events routinely prompt discussions about general issues and related principles. A nine-year-old is accused of murder, and the discussion in the media turns to the general (and philosophical) question "At what age should a person be held accountable for doing wrong?" which involves the related question "What does it mean to *know* what is right and wrong?" People leaving a gallery might begin to discuss the artworks of Cy Twombly *in particular*, and move on to questions about art *in general* as they wonder what makes good art. Philosophical inquiry is embedded in experience and our attempts to make sense of our world.

We not only raise philosophical questions, but we also often continue to examine them, sometimes referring to views we've read or heard about, even as we clarify and state our own views. This is a human process, one we partici-pate in throughout life. When we do, we're taking part in philosophical inquiry.

Philosophy and Its Branches

From the Greek *philein*, which means "to love," and *sophia*, which means "wisdom," philosophy suggests the love of wisdom. In our search for wisdom, we have offered various explanations for or theoretical positions regarding concepts such as reality, truth, knowledge, and goodness. We have stated what we believe to be real, what constitutes truth, how we can know what is true, what is good and right, and how we can know what is good and right. We have categorized the questions and have given them names. In Western philosophy, for example, *metaphysics* is the name we have given to questions that consider reality and knowledge (*ontology* and *epistemology*, respectively). *Ethics* is the name we have given to questions and explanations about goodness, right, and wrong. These areas of inquiry are often referred to as the branches of philosophy.

Aesthetics as a Branch of Philosophy

Aesthetics is the branch of philosophy that deals with issues of beauty or the beautiful. The questions and ideas of aesthetics have been directed toward what society considers art: the creation of and response to art, the role of art in society, and the standards for judging art's significance and for interpreting its meaning. In addition, aesthetics deals with our experience of beauty and ugliness outside of art—in nature, for instance. When the museum visitor asked if art is good simply because an artist does something that no one else has done before, she was asking a philosophical question. It was philosophical because it addressed standards for art in general, not just the standards for judging the work of the particular artist. Because this question had to do with an attempt to determine standards for the judgment of artworks in general, it falls within aesthetics.

In cultures worldwide, people have ideas and beliefs about things that they make and the ways in which they respond to such things. Differences in values and beliefs about the world and their place in it, along with differences in language and custom, account for differences in the ways in which people

1.1 *The Mission Inn wrapped for extermination of termites, Riverside, CA. Photo: Fred Bauman.*

1.2 *Christo and Jeanne-Claude,* Wrapped Reichstag, Berlin, *1971–95. Silver polypropylene fabric, blue polypropylene rope. Photo: Wolfgang Volz.*
© *Christo, 1995.*

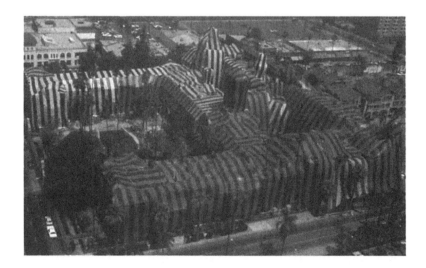

consider these things. In most cultures, even if no word exists for art, there is likely to be language that accounts for something that is "good to look at" and for a contemplative mode having to do with aesthetic appreciation.[1] This kind of thinking may or may not be organized into categories and subject to study, as it is in Western philosophy. Aesthetics as a branch of philosophy is a Western construction.

Questions about Artworks

Within Western tradition and many other cultural traditions, questions in aesthetics can be categorized by considering their particular focus. Some questions center primarily on the work of art: What *is* art, after all? Are there certain things that all works of art have in common? Is there one, true, and universal definition of art, or do definitions change over time and throughout the world? Other questions concern certain kinds of art: What is sculpture? What makes a photograph different from a painting? What are the distinguishing characteristics of computer-generated imagery? Aesthetics is concerned not only with visual

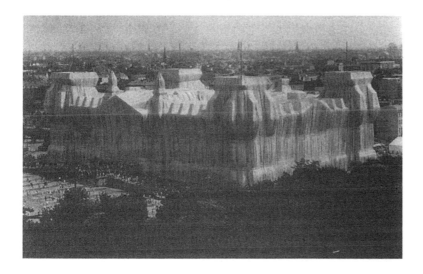

Discussion Point:
When Is It Art?

Twenty-four years of effort by the artists and their team of advocates culminated in the 1995 wrapping of the Reichstag. For two weeks, the historic Berlin building stood draped by 1,076,000 square feet (100,000 square meters) of fabric, including tailor-made panels for the facades, towers, and roof. *Wrapped Reichstag* utilized 51,181 feet (15,600 meters) of rope and 200 metric tons of steel. This project is one of several in which artists Christo and Jeanne-Claude, in collaboration with hundreds of other people, have draped objects in several parts of the world. Other projects included surrounding eleven islands in Miami's Biscayne Bay, wrapping one million square feet of Australian coastline, and creating a 30-mile (18.6 km) installation of 1760 yellow umbrellas north of Los Angeles and installing 1340 blue umbrellas north of Tokyo.

The Mission Inn is a National Register landmark which had been visited by presidents Theodore Roosevelt and William Howard Taft. As part of the restoration of the inn, exterminators covered the building with brightly-colored tarps.

How is this different from *Wrapped Reichstag*? Is the Mission Inn covered with tarps a work of art?

philosophy

1 a. Love and pursuit of wisdom by intellectual means and moral self-discipline. b. The investigation of causes and laws underlying reality. c. A system of philosophical inquiry or demonstration.

2 Inquiry into the nature of things based on logical reasoning rather than empirical methods.

3 The critique and analysis of fundamental beliefs as they come to be conceptualized and formulated.

4 The synthesis of all learning.

5 All learning except technical precepts and practical arts.

6 All the disciplines presented in university curriculums of science and the liberal arts, except medicine, law, and theology.

7 The science comprising logic, ethics, aesthetics, metaphysics, and epistemology.

8 A system of motivating concepts or principles: the *philosophy* of a culture.

9 A basic theory; a viewpoint: an original *philosophy* of advertising.

10 The system of values by which one lives: has an unusual *philosophy* of life. [Middle English philosophie, from Old French, from Latin philosophia, from Greek, from philosophos, lover of wisdom, philosopher. See PHILOSOPHER.][2]

art, but also with other forms, such as music, dance, theater, literature, and film. Aesthetic theories can be even more focused: they might, for example, examine the distinguishing characteristics of jazz as a form of music, or of tragedy as a form of literature.

Questions about Makers

Some questions are primarily about the maker; the activity of making; and the relationships among the maker, the making, and the artwork. We might ask, for example, "What does it mean to create a work of art?" "In what ways is an artwork an expression of the maker's emotions?" "Are there certain things that all artists have in common?" In the Western world, where there has been a tendency to separate art as a special kind of object or activity, separated from ordinary objects and activities, philosophers have pondered whether an artist must intend to create a work of art in order for the work to be art, thus focusing on the mental state of the artist as an important consideration. When reflecting on the nature of the artist, some philosophers have offered views about the idea of the artist as *genius*. Some thinkers have focused on the relationship between the artist and morality, raising questions and proposing views about the artist's moral responsibility and the like. Others have suggested that the artist is inextricably linked to the perceiver of a work of art, that the artist somehow represents the perceiver of the work as she or he creates it. In cultures in which there is no separate set of ideas about what we in the Western world would generally refer to as art, people have beliefs about the role, value, and significance of things that they make and the members of their group who make them. What these questions and explanations share is a focus on the maker of the artwork as a way of understanding significant characteristics of art.

Questions about the Artist

Willem de Kooning, a leader in the abstract expressionist movement, suffered from Alzheimer's disease from the early 1980s until his death in 1997. He continued to paint until his death, but increasingly with the help of studio assistants. Because of the kind of illness he had and because it is unknown how much help he received from his assistants, his late paintings have provoked controversy. The critic Peter Plagens asks, "Could an artist increasingly unaware of his surroundings create good, let alone, great, art? Was there enough of de Kooning's hand in the very last ones to call them his?"[3]

At issue in this case is the question of what constitutes collaboration. There are concerns that de Kooning's assistants did much of the painting in his later works. The extent to which an artist must be in full charge of his mental (and physical) capacities in order for his works to be considered authentic is at issue with concerns about de Kooning's disease. When de Kooning's later works were to be exhibited at the Walker Art Center in 1996, curator Gary Garrels convened a panel of experts to determine when the artist's works began to lose coherence. Whether artworks created by someone suffering from alcoholism or depression would be subjected to the same scrutiny as someone suffering from Alzheimer's disease is also at issue.

There are other perspectives on the mental state of the artist. Michael Vincent Miller, in a review of a book on the art of the insane, notes that there is a romantic ideal of madness, which considers the insane artist as a "hero on the fringe, a lonely plunger into hidden recesses of human nature, an explorer of shadowed, abysmal depths . . . Some Expressionist and Surrealist painters deliberately imitated the works of schizophrenics . . . others sought ways to drive themselves into crazed states of mind."[4] Miller asks, "If there is a border between the crazy and the inspired in art, it has not been mapped, so how do we know there is a difference?"[5]

Questions about Viewing Art

The film critic Janet Maslin has noted that many contemporary films are marketed and presented as "based on a true story." She wonders, "Precisely what does this information contribute? Is it meant to make an otherwise skeptical audience stop questioning what it sees on the screen?" She says that some films contain enough authentic-looking touches that there is no need to tell the audience that they are based on the truth. But she also says that knowing that something is "history come to life" can be an essential part of a film's mystique. However, she suggests that when the "true story" addition to the title is used too freely, it is no longer a means of providing information; rather, it "becomes a way of short-circuiting the viewer's imagination. No longer is the job of letting a work of art take root in the imagination really necessary."[6]

Questions about Perceivers

Considered broadly, the perceiver is the viewer, listener, or audience member encountering the work of art. Some of our philosophical questions focus on perceivers and their relationship to the work. We ask what the role of our prior experiences is as we encounter, perceive, and respond to an artwork. We sometimes wonder about how we construct meaning as a result of our experiences with artworks, by asking "What constitutes a plausible interpretation of an artwork?" and "Are interpretations true?" We might ponder, for example, whether there is a *best* way to approach and respond to artworks. Within the Western tradition, considerable attention has been paid to the idea of an "aesthetic experience": what it is, under what conditions one "has" an aesthetic experience, and so on. People have beliefs about ways in which they respond to and use artworks. When we focus on the perceptions, interpretations, and judgments of perceivers, we often enter into discussions about the nature and role of our talk about art—what we can hope to learn from a critic's account of a work of art, for example, or what the activity of art criticism involves.

Questions about Context

Some questions deal with the world—the social, historical, political, and temporal context in which the artwork is made and/or perceived. Some questions along these lines might be "How does the socio-historical context in which a work of art is made influence the process of making or the artwork itself?," "To what extent does the socio-historical context affect the way in which a perceiver responds to an artwork?," and "What is or should be the role of the artwork in culture?" Related to this, we ask, "What is or should be the relationship between art and morality? Between art and politics?"

Considerable attention in the Western tradition has been directed during the later part of this century on the notion of the "artworld." The artworld has been construed loosely as a group of institutions within a society that confers the status of "art" on, or in other ways values, those things created by members of their group. The concept of the artworld has come about through our questions and ideas about the context in which an artwork is created, used, interpreted, and judged.

The Aesthetician

Philosophers who primarily address these questions about artworks, makers, perceivers, and context—questions in the branch of philosophy known as aesthetics—are called aestheticians. Not surprisingly, the questions raised by aestheticians are the questions that many of us raise when we stop long enough to think about art and our experiences with it. When she asked whether an artwork is good because it is different from any other artwork created, our museum visitor was asking about the role of originality in determining the value and significance of art. Originality as a standard for judgment raises the question of whether an artwork can ever be original. Ideas and knowledge are not "caught" or "found," it is argued. As social beings, we collectively construct knowledge and ideas. If this is the case, then no artwork can be said to be the original idea of any one person. This issue relates to some recent philosophical ideas about reality, the place of the individual in society, and how we come to have knowledge. Current issues in aesthetics, like the issue of originality, often spring from current ideas in the other branches of philosophy and, indeed, from current ideas that cross over all areas of thinking and doing.

Aesthetics and Art Criticism

Teachers often ask about the difference between aesthetics and art criticism. We engage in art criticism when we focus our attention on the meaning and significance of a particular work of art or body of work. Art criticism involves taking account of what is presented, constructing interpretations, and making judgments of the merit or significance of the work or body of work. Our beliefs about art and the relationships among art, makers, perceivers, and contexts—our philosophical beliefs—support our attempts to construct meaning and to make judgments about quality. Just as beliefs about these matters vary from culture to culture, so too do the ways in which people in different cultures consider the appropriate way to interpret and judge artworks.

Although our philosophical beliefs are importantly related to our involvement in art criticism, the distinction between the two processes has to do with specificity. Aesthetics, or philosophical inquiry, has a broader focus, in that we are concerned with art, beauty, and our experiences with art and beauty *in general*. We use such words as *all*, *every*, and *always* as we ask such questions as "Do *all* artworks have expressive properties?," "Does *every* experience with a work of art carry with it certain attitudes or feelings?," or "Do artworks *always* tell us something about the culture in which they were produced?" Note that our interest in asking these questions is not with particular works, but with works of art in general.

In practice, we often move back and forth between art criticism and philosophical inquiry, because in attending to the meaning and significance of particular artworks, we may well wonder about the sort of things suggested by the philosophical questions mentioned above. We may or may not be aware of these beliefs as we engage in art criti-

MY NAME IS: Lindsay Hagan
MY PERSONAL DEFINITION OF ART IS:

Art has colors. sometimes art tells stories. Sometimes art tells messages. Art can be beautiful, art has swirls, Art has particles and art can be diffrent shapes and sizes.

MY NAME IS: Denise
MY PERSONAL DEFINITION OF ART IS:

Art is anything made by something or someone. Art has to be made with shapes, size, and color. You have to see art. It has to have designs. It should look neat. It could look boring. It dosn't have to look like something.

1.3 to 1.6 Illustrations with personal definitions of art.[1]

cism, as we perceive artworks, interpret their meanings, and judge their merits. If we are discussing a particular work of art with others, our views will likely be different. As we explore our different views about the meaning or significance of a specific artwork, we may well move into a discussion of our beliefs about art in general—our philosophical beliefs—on which our different interpretations or judgments are based. We may wonder about how it is that people living in communities often share beliefs about what is valuable, what kinds of artworks are most significant to their life, and about how artworks are used and appreciated within these communities.

Engagement in art criticism often prompts philosophical questions about the process itself. For instance, when attempting to interpret a work of art and discovering that several interpretations have been offered, we may well ask whether there can be more than one plausible interpretation of an artwork. We may wonder what constitutes a good interpretation or a sound judgment. As we attempt to interpret the meanings of specific artworks, we may wonder about whether and to what extent we need to have knowledge of the artist's intentions or other contextual information regarding the creation of the work. While philosophical questions and discussions also emerge from our experiences in making art or considering it historically, they seem to be especially prevalent during our involvement in art criticism.

Philosophical Inquiry and Children

Among the multiple phobias that have been identified for us in recent years, I sometimes think we should add "philosophy phobia." People are often hesitant to enter into the study of philosophy for a variety of reasons, one of which is the suspicion that the terminology is foreign, difficult, and convoluted. To career-oriented students, philosophy as a subject

to be encountered in university courses seems far removed from their immediate needs. There is a perception that philosophers only think, talk, and write—that their world is one of thought, not action. Our action-filled world dictates that there is no time to while away hours by simply thinking. This view of philosophical inquiry fails to recognize the dynamic potential of philosophical discussions to help us clarify and refine our ideas. It also fails to recognize how our ideas are importantly connected to our actions and how much more meaningful our actions are when seen in light of larger visions of the world and our place within it. As Plato quotes Socrates, "The life which is unexamined is not worth living."

Children have beliefs about art and often raise philosophical questions about art. As we acquire language, we acquire concepts. As children learn to use the term "art," they learn how the term is most often used within their language community. They may not be aware that they have beliefs about art, but they bring their beliefs to bear upon the comments they make and the questions they ask. For instance, when a child worries that her artwork is too much like another child's and is therefore not good, she probably holds the belief that an artwork is good to the extent that it is original or unique. The origin of this belief cannot be specifically identified; it is the sort of assumption that we learn indirectly from being in a particular language community. Most teachers of art have experienced the situation in which students wonder why a certain work of art or a certain kind of art is thought to be good. They ask, "Why is this art?" and make comments such as "Even I could have done *that!*" When students raise such issues, they typically subscribe to certain beliefs about what art is and also what *good* art is. These beliefs become more meaningful when they have been examined and their implications made explicit.

1.5

MY NAME IS: Matthew Kim
MY PERSONAL DEFINITION OF ART IS: I think people make Art. I think animals can't make Art because, they don't think like people. Some pictures people draw not Art becau... some people hurrie up and make thir Art look ugly. Computers can man Art. Art is done in different ways.

1.6

MY NAME IS: Josh Mclotl...
MY PERSONAL DEFINITION OF ART IS:

I think art doesn't need design. People are not the only thing that can make art machines can. People may look at a picture and think it isn't art and how other people might think it is art. Anything that you draw is art. Animals can't draw. Art can be anything because it has beauty.

Assumptions Guiding Practice

Capitalizing on the tendency of children to ask why, and having an interest in helping children develop the thinking skills required to address their queries, several philosophers and educators have developed strategies for teaching students how to take part in philosophical inquiry. Increased attention to teaching aesthetics has followed a widespread emphasis on broadening our conceptions of art education, and has led to recommendations that the study of art include emphasis on art-historical inquiry, art criticism, and studio production, as well as aesthetics or philosophical inquiry.[8]

As is often the case with recommendations or prescriptions for curriculum development, certain assumptions about children and philosophical inquiry support most discussions about teaching aesthetics as a type of philosophical inquiry. These assumptions include the following:

Assumption 1
Children have beliefs about art.
Children have beliefs about making, perceiving, and responding to art; and about the role of art in society. Children formulate their beliefs out of their experiences, and because children's experiences are widely varied, so too are their beliefs. Some children have more deeply embedded beliefs than others. All children, however, are influenced by their beliefs when they make decisions about objects they create and when they respond to objects created by others.

Assumption 2
Children raise questions about art.
Children often raise questions about making, perceiving, and responding to art; and about the role of art in society. Like the woman leaving the Museum of Modern Art, they sometimes wonder whether

something considered art by others is, indeed, art. Depending on their beliefs, they may question why an abstract painting, for instance, is considered good when it fails to correspond realistically to things they have seen in the world. Children may question the merit of a work of art that makes them feel sad, believing that art should make people feel good or happy. A child may question whether it's a good thing to have art that shows bad things happening, believing that such art condones bad behavior. In this case, the child might well believe that art should have a positive effect on behavior. Children may believe that artworks should not be messy. They might find that much of what is considered art is messy, which prompts questions about its merit. Indeed, they might consider some of their own artworks to be messy and therefore not worthy of serious attention. Because they hold certain beliefs and encounter experiences that call their beliefs into question, children readily and routinely ask philosophical questions.

Assumption 3
Children can and should reflect on their beliefs.
One of the most important goals of schooling is to broaden children's experiences and thus their conceptions of the world. Within the area of art teaching, there is much to be gained by providing opportunities for children to reflect on their beliefs and their questions about art and related concepts and ideas. This is accomplished by challenging their beliefs, whether by showing them artworks that fall outside their conceptions of art, or by exposing them to thinking that does not correspond to their own. Critical reflection about the merits of one's beliefs cannot take place without awareness of these beliefs.

Another broad goal of schooling is to develop children's critical thinking. A child can learn to think critically about art-related matters through an exam-

ination of the merits of competing beliefs. Critical thinking can be addressed through the teaching of art when students are given opportunities to think seriously about art, their perceptions of and response to art, and the role of art in culture.

Assumption 4
Children can and should discuss their views with others.
While it is certainly good to have children be reflective about their own beliefs and questions about art, they can benefit further by discussing their beliefs and questions with others. In such discussions, children see that not everyone necessarily shares their beliefs. If the rules of discussion include listening carefully and withholding judgment, children can seriously consider other views; they can "try on" and weigh the merits of the competing views. Children may find that a change in belief makes sense. Or, they may find that even though an alternative view has merit, they do not change their beliefs but do learn to respect the alternative view.

Assumption 5
While engaging in philosophical discussions, children can and should develop their skills in good reasoning.
In order to reflect on their beliefs and to discuss philosophical issues related to art, children must develop their abilities to listen well, to make distinctions, to identify assumptions, to offer carefully constructed reasons for their views, to raise carefully constructed questions about the views of others, to weigh their own reasons and those of others for particular views, and to imagine alternative solutions to issues. Reasoning skills can be taught directly and indirectly, and can be refined through practice.

Assumption 6
Critical-thinking skills can be transferred between areas of the curriculum.
The development of good reasoning skills is an overarching goal of education. Critical-thinking skills are taught and practiced in other areas of the curriculum, and they can be taught and practiced within an art program. Art teachers can help learners understand how critical-thinking skills developed in other subject areas can also be used in art. Accordingly, teachers of other subject areas can help learners transfer the skills developed in art to these other areas.

Assumption 7
Engagement in philosophical inquiry is integral to engagement in the study of art.
Students in art classes make objects that connect to their experiences, dreams, and ideas. They also respond to their own artworks and those of others in an effort to understand themselves and their relationships with the broader world. In a curriculum that helps them in these efforts, students learn how to carefully consider their own artworks and those of others in their social-historical contexts, seeking to interpret their meanings and judge their merit. Making art is connected to beliefs about art—what counts as art, what makes an artwork meaningful and good, and how art reflects individual and social beliefs. Response to our own art and that created by others is also connected to such beliefs. Art-making and responding is intentional, authentic, and meaningful to the extent that we are aware of the implications of the activity. Without opportunities to reflect critically on their beliefs about art, students tend to view art-making as a chance to simply manipulate materials, and art viewing as a time to offer thoughtless reactions to artworks.

Student Writing

In this journal entry, a student reflects on her involvement in a collaborative performance of *The Dream Jacket*.⁹

"The Dream Jacket was a piece that I will never forget. It connects to things that we have learned about art. It speaks to the whole idea of process and the issue of product. It put the emphasis on think-ing and imagining and not on the prod-uct. What is a product anyway? It's just physical evidence of what goes on in the mind. I really think that this taught me more. It focused on the messy way that you think about things . . . They aren't clear at first. This piece all came together in the end and that was good, but the important part is what it taught us about thinking and feeling in art. The performance . . . was . . . something that will remain in my memory and will be in other people's memories too. But it will all be different; we each know this work in a different way. Isn't that what art is? We bring different experiences to the work and come away in different ways, but we are all connected by the work. It's a way of connecting people and pro-viding commonality and seeing things and finding ground to talk about."

—Denise, high school

Philosophy and Messy Rooms: A Closer Look at Children and Philosophical Inquiry

Students' participation in philosophical inquiry is a bit like their organizing their bedroom after several weeks of tossing belongings rather than putting them back in order. Fresh and not-so-fresh shoes, socks, sweaters, and other assorted pieces of clothing have settled in with books, games, puzzles, dolls, toy animals, rocks, seashells, maps, and other assorted playthings. The task of straightening such an array can be daunting. With minimal help, most children can begin the process of organizing their rooms by sorting their belongings into categories, reserving one pile for clothes, one for books, one for dolls, and so on. Most children are quite capable of proceeding in this way, even though they may require a little nudging to keep them focused. Once children under-stand the categories, they can easily return their belongings to an ordered state. Similarly, when chil-dren take part in philosophical inquiry, they create or adopt categories to help organize future experiences with art-making and viewing.

Sometimes, the organization—of a room or of ideas—runs smoothly, but at other times, there is reason to stop and think hard about the process. What happens, for example, when an object defies categorization? Consider an object that has a binding like that of a book and, judging from its outward appearance, would therefore be placed with other books. What if this booklike object folds out into a marvelous three-floor dollhouse of rooms, walls, win-dows, and even furniture that pops up with the other features? Onto which pile—books, toys, dollhouses— should this object be placed? To make a decision, the child must consider the limits of the concept of "book." Can something be a book if it does not have text? Can something be a book if it does not have pages? Should there be a new category for objects

such as this, or should the category "book" be expanded?

Like the philosophers who attempt to organize particulars into coherent frameworks, children need to organize their experiences through sorting, categorizing, establishing and discovering connections, and finding differences, in order to establish their own frameworks for understanding. As with the book that turns into a dollhouse, students sometimes find that they need to alter their frameworks. They add new categories or extend old ones. At times, beliefs that they held for a long time are exposed as false, or are at least on shaky ground. Even when their beliefs remain unchanged, however, students who reflect on them are more aware of their reasons

1.7 *Bill Owens,* I wanted Christina to learn some responsibility for cleaning her room, but it didn't work, *1972.*

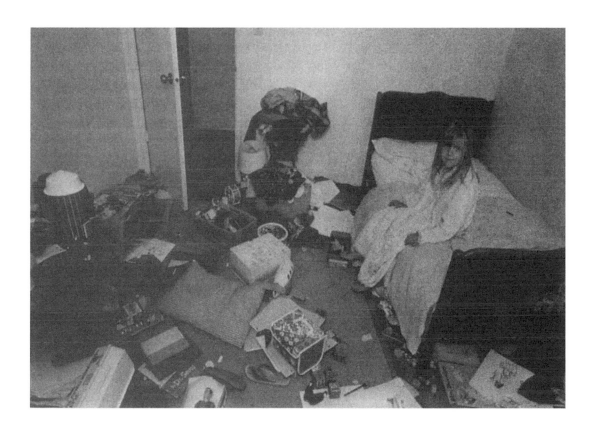

for holding them. If in the process of philosophical inquiry, other people have been involved, students may learn that there are reasonable alternative points of view. They may also learn that issues are sometimes more complicated than they might have thought. Students learn to be reflective and to use their abilities to think critically about important issues. The lessons learned through engagement in philosophical inquiry are educationally relevant in the broadest sense.

Philosophical Inquiry and the Art Curriculum

Aesthetics has been taken into the classrooms by teachers who have recognized the importance of doing so. These teachers incorporate the concepts and skills of philosophical inquiry into units of study, and integrate the content of aesthetics into provocative learning experiences for their students. Throughout this book, reference is made to teaching strategies and resources designed by these teachers. What both practitioners and theoreticians suggest is the addition of philosophical inquiry to a sequential, balanced curriculum in art as a significant way of fostering a reflective and meaningful involvement in the study of art.

In balanced units of study, students examine artworks made by themselves and others, describe what they see, and construct plausible interpretations of what they perceive. They take part in art-historical inquiry, learning about the origins and traditions associated with the artworks. Their own decisions about making art are informed by this participation in the world of art, and their own works represent meaningful encounters with materials and techniques, and more importantly, with ideas. As they think philosophically about art, they make connections between what they perceive, interpret, understand

culturally, and create. As with all components of the art curriculum, their experiences in philosophical inquiry are sequential, so they build upon skills and integrate concepts of increasing sophistication.

When the art curriculum includes aesthetics as an integral component, philosophical discussions are a regular occurrence in the art class. Students are asked to think, talk, and write about philosophical issues. As they participate in philosophical inquiry, they refer to some of their prior experiences in interpreting meaning and judging the significance of different works of art, to their previous encounters in making art, to their growing understanding of the cultural traditions informing the creation of artworks, and to their own evolving beliefs about art. Through philosophical discussions, they experience developing lines of reasoning. They increasingly choose their words more carefully, identify "hidden" assumptions in their own and classmates' positions, make distinctions as they put forward their arguments, and carefully respond to arguments put forward by others. A comprehensive curriculum in art includes opportunities for students to systematically learn concepts and skills associated with philosophical inquiry.

When students are asked to think about the nature of art and their experiences with it, they are moved to probe the conceptual structure through which they understand the world. In the process, they make distinctions, see connections, and often ask new questions. The process is enhanced by conversing with others who, in similar attempts to make sense of experience, articulate their beliefs and present reasons for holding them.

This chapter introduced aesthetics as a particular kind of philosophical inquiry. Philosophy is the name that we have given to the consideration of the many important questions human beings have asked over time. People have wondered about what counts as truth, what is real, what it means to have knowledge, and what it means to call something beautiful or "art." Aesthetics is the branch of philosophical inquiry in which we address questions about beauty, art, our experiences with art and beauty, and what we can legitimately say about the meaning or significance of artworks.

Children ask philosophical questions and have beliefs about art and other aesthetic issues, and teachers can develop curricula in which students have opportunities to engage in philosophical inquiry. In the process, students raise questions, reflect on their beliefs, challenge themselves and others to formulate positions, and sometimes change their positions when appropriate. Philosophical inquiry is not something separate from the day-to-day experiences in the artroom; rather, it is an integral part of being a reflective, involved student of art, who thereby learns skills that can enhance the overall character of life.

Notes

1 Jacques Maquet, *The Aesthetic Experience: An Anthropologist Looks at the Visual Arts.* (New Haven: Yale University Press, 1986), 58–59.

2 *The American Heritage Dictionary of the English Language*, 3d ed. © 1992 by Houghton Mifflin Company. Electronic version licensed by InfoSoft International, Inc. All rights reserved.

3 Peter Plagens, "The Last Dutch Master," *Newsweek*, 31 March 1997, 69.

4 Michael Vincent Miller, review of *The Discovery of the Art of the Insane*, by John M. MacGregor, *The New York Times Book Review*, 17 December 1989, 24.

5 Ibid.

6 Janet Maslin, "Just Because It's True, Is It Art?" *New York Times*, 27 March 1988.

7 Students of Jeffrey Dietrich, art teacher, at Oley Valley Elementary School, Oley, PA.

8 See, for example, Gilbert Clark, Michael Day, and Dwaine Greer, "Discipline-Based Art Education: Becoming Students of Art," *The Journal of Aesthetic Education* 21: No. 2, (1987): 129–193.

9 *The Dream Jacket* was a collaborative artwork involving a professional music group, "Bodo," a dance troupe, "Prairie Wind Dancers," and visual arts students from Wichita East High School, Wichita, Kansas. Art teacher Brenda Jones asked students to reflect upon the performance art experience.

Aesthetic Theories and Philosophical Questions

When we begin to think about art—its origins, meaning, significance, and role in society—we raise questions that have been asked for centuries and across cultures. Because the world, human interests, and art change over time, the nature of these questions has varied in subtle ways, as have the responses. Even so, an instructive exercise is to note how our own beliefs and those of our students correspond to the theories put forward throughout history.

This chapter first provides an overview of theoretical perspectives about art and our experiences with it. Some useful distinctions are then made for teachers identifying philosophical questions and helping their students also to recognize them.

Aesthetic Theories

To engage students in philosophical inquiry about art, teachers need not be familiar with all facets of aesthetic theories. Indeed, teachers who have no knowledge of the history of aesthetics may involve their students in philosophical inquiry. However, encouraging students to see that their views are not necessarily unique, and that others who have held similar beliefs have written them down to be studied and reflected on, is useful instruction. This also aids students in understanding their connections to others; they come to know that they are part of an ongoing dialogue among people, over time, who have thought about art and their responses to it. Teachers who are familiar with various aesthetic perspectives can better plan for philosophical inquiry within the curriculum. Dialogues will be richer to the extent that teachers are able to see student comments in light of those offered by others. As they explore themes, topics, and questions for philosophical focus, teachers can draw on their increased understanding of the complexities involved, the related issues and questions, and the various positions that have been taken with respect to them, in order to design units, lessons, and activities.

What Is a Theory?

A theory is an attempt to explain a certain set of phenomena or a single phenomenon. The physicist who explains why a ball will bounce when thrown against a hard surface, why the distance it bounces will depend in part on the hardness or softness of the surface, and why some balls bounce farther than others when thrown against hard or soft surfaces is providing a theory. Like scientific theories, aesthetic theories are also attempts to explain phenomena; in particular, the human experiences, the range of objects, and the varied events associated with beauty and art.

Often, in attempts to address philosophical questions about art, explanations are based on broader philosophical views about the world and our place in it. Theories of art sometimes can be seen as part of broader theoretical frameworks. Plato, for example, proposed a theory of art that was part of a larger philosophical view that included theories of reality, truth, knowledge, human nature, and society. Other philosophical positions about art can similarly be placed within larger frameworks. This is also true with those of us who are not philosophers, as such. We can often identify beliefs about art that are consistent with beliefs about other important issues in the world.

A Word about Categories

An artwork is relational: it always exists in relation to other things, people, or events. Someone makes the artwork, so the artwork always stands in some kind of relationship with the art-maker. An artwork is made in a certain time and place, when certain ideas are prominent within the culture. An artwork is also responded to in a certain time and place, within certain ideological contexts. Interestingly, the context in which an artwork is made is not always the context in which it is experienced. Responders vary. Individuals and groups change, as do the circumstances under which these individuals or groups respond to art. When we offer explanations about art and its significance, we do so with assumptions about artworks *in relation to* makers, perceivers, and the contexts in which artworks are made and/or perceived. One way in which aesthetic theories differ from one another is in the degree of emphasis placed upon these relationships.

Aesthetic theories can be comprehensive or limited. The focus of an aesthetic theory might be limited to the notion of the creative process in considering the relationship between the maker and art object, for example. A more comprehensive aesthetic theory might begin with the relationship between the maker and the art object, but include implications for the other relationships based upon this view.

When teachers are familiar with different theoretical positions, they may wish to draw on them for use as starting points for discussions or as models for the development of points of view. The categories of aesthetic theories outlined below are easily grasped, and students can be encouraged to consider how and in what ways their own beliefs correspond to them. As with most category systems, a particular belief may fall into more than one category, or categories may overlap. Being familiar with types of theories is not so that we might pigeonhole a statement or belief. Rather, the knowledge helps students and teachers generally organize their own thoughts about art and what others have said or written.

Theories and Our Responses to Artworks
Most people have beliefs associated with making and responding to art. When making judgments or offering interpretations about works of art, people tend to rely on their own set of beliefs about art. These beliefs often suggest one or more traditional theories of art.

Elvis on Velvet
Black-velvet paintings often depict such subjects as cowboys, clowns, leopards, tigers, and praying hands, and are rarely displayed in art galleries or museums. One of the most common subjects is Elvis Presley. Student responses to one Elvis painting on

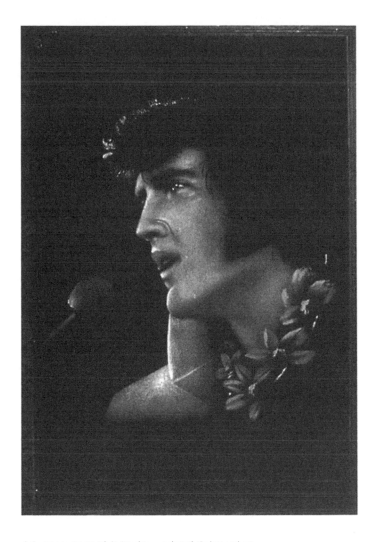

2.1 Anonymous, Elvis Presley, undated. Paint, velvet, 28 x 39" (71 x 99 cm). Courtesy Jennifer Heath. Photo: Caroline Hinkley.

Some Facts about Velvet Paintings[1]

- In the mid-nineteenth century in England, wealthy young women were expected to be accomplished in the art of painting on velvet, which was considered part of a cultured hobby.

- In the 1930s, Mexican-based companies began mass-producing black-velvet paintings.

- One Mexican firm currently employs a small staff of painters. Each painter makes about ten paintings a day; the firm turns out about 3,000 paintings a week.

- The subjects of black-velvet paintings depend on what is popular. A painting might depict unicorns, Clint Eastwood, Michael Jackson, or some other star of the moment.

- Many velvet paintings are appropriated from famous paintings such as *Mona Lisa* or *The Last Supper.*

- Some contemporary artists work in black velvet: Julian Schnabel, Peter Alexander, Eleanor Dickinson, and Paul Mavrides.

velvet show the way in which theoretical perspectives can influence responses to artworks.[2] Each response suggests a different theory.

Formalist Theory

"That painting of Elvis on velvet is a good painting because it is composed well. It has balance, and the color choices help to lead the eye around the entire work."

The student who offered this positive judgment of the Elvis painting used standards that have to do with the formal arrangement of the parts of the painting. She might have mentioned other formal qualities, such as texture, line, space, and form. Formalism, the theory that holds that artworks have the capacity to elicit a significant response if they are arranged appropriately, has dominated Western thinking about art during the twentieth century. If asked to say more about why balance and good composition are important, the formalist might well say, "It just works," which means for many that the arrangement has the capacity to elicit a significant response. Clive Bell and Roger Fry, major proponents of the Formalist theory, talked about this elusive arrangement as "significant form."

The Formalist theory of art has its roots with those who have talked about a particular kind of experience that we can have when considering beauty or artworks that embody beauty. This "aesthetic experience" is thought to be best when the artwork that triggers it is well organized. According to this view, the elements of art and the aesthetic experiences prompted by art are thought to be universal, extending beyond cultural or historical contexts. Thus, for those who first put forward Formalist ideas, aesthetic experience need not be limited to those educated in art history or familiar with the origins of

and nuances in art produced in unfamiliar cultures and places. Given this view of the universality of good form in art, Formalism was thought by its first proponents to be more democratic than other theories of art. Theorists in the last few decades, however, have been increasingly critical of Formalism and its attendant views of the world because it guided the creation of art valued for its form alone. As works of art became increasingly about themselves, and not about things of importance to the general public, people became alienated from and distrustful of art.

According to Formalist thought, each kind of art—such as painting, music, and poetry—has certain elements arranged according to principles. For an artwork to be well organized, these elements must be arranged in accordance with the principles associated with the particular art form. Thus, Formalist assumptions can guide the perception, understanding, and appreciation of all kinds of art, not just visual art. For the Formalist, things such as subject matter, moods or feelings, social issues, and artists' intentions are external to the artwork and do not have aesthetic significance. They are incidental at best and possibly harmful in that too much attention to them will work against having an aesthetic experience. While other kinds of aesthetic theories do not rule out the significance of formal arrangement of the parts of the work, they focus on other aspects of art or relationships associated with art.

Expressionist Theories

"That painting of Elvis on velvet is a good painting because of the feelings it expresses. One cannot avoid noticing the look of sadness in the singer's eyes and see how this sadness is coupled with pride. All parts of the painting—the colors, the brushstrokes, the way the singer is positioned—add to the overall mood of the work."

"Art for art's sake is a philosophy of the well-fed."[3]
—Cao Yu, Chinese dramatist, 1980

"The history of modern art is also the history of the progressive loss of art's audience. Art has increasingly become the concern of the artist and the bafflement of the public."
—Henry Geldzahler, Belgian-born American curator and art critic

"Art is the objectification of feeling."
—Suzanne Langer, American educator
and philosopher, 1967

"Art is a form of catharsis."
—Dorothy Parker, American writer

"An artist can evoke emotions even if he
distorts the natural order of things, what
we call 'reality.'"
—Isaac Bashevis Singer, American writer

This student has judged the painting of Elvis as a good painting on the basis of its capacity to express moods or feelings. Philosophers who have presented Expressionist theories of art have focused on and explored the potential of artworks to express feelings. Some Expressionist theorists have talked about the capacity of artworks to evoke certain feelings. Tolstoy thought that a feeling that is felt by the artist is communicated through the art, suggesting that the perceiver, in experiencing the work of art, is moved to feeling a certain way, presumably the same way the artist felt.

Expressionist theories are compelling because most of us acknowledge that feelings or emotions are powerfully tied to artworks and our experiences with them. Students are quick to note "sad" or "happy" pictures, for example, and to talk about artworks in such ways with little difficulty. These theories are philosophically interesting, however, because it is hard to explain how it is that something physical—an object—can express or elicit something so subjective or private as an emotion. As students become more experienced in thinking philosophically, they too will wonder how a picture can be sad or happy, since we usually talk about only people being sad or happy. They might even wonder if a happy artist can produce a sad picture, and if so, how this works.

While the Formalist pays little attention to subject matter or feelings expressed in art, those who subscribe to Expressionist theories often will attribute the expressive character of an artwork to the formal elements—such as color, line, texture, and use of space—which, with subject matter, help create the feelings expressed or evoked by the artwork. Within this perspective, the formal elements are significant, but only insofar as they are involved in expressing or evoking feelings.

Contextualist Theories

In attempting to offer explanations about artworks and our experiences with them, some theoreticians have focused on the social, political, and historical contexts in which artworks are made and encountered.

Contextualist theories can be organized into three general types: Instrumentalist theories, Institutionalist theories, and Linguistic theories.

Instrumentalist Theories

"The painting of Elvis on velvet is significant because it helps to keep alive the memory of someone who was so important in the history of music."

This student values the Elvis painting because of what it *does*. The focus is not on the way the elements of the painting are organized; nor is it on the mood or feelings expressed or evoked. Instead, the artwork is valued for the role it plays in our social history. This view falls within the category of Instrumentalist theories. Sometimes referred to as Functionalist, these theories hold that art is and/or should be primarily functional: it does or should do something significant. Some Instrumentalist theories of art are tied to broader ideological views. Marxism, for example, is a general explanation of reality, knowledge, human nature, and value that has implications for the way we understand, make, and respond to art. Professing that artworks embody the interests and values of the dominant class of a culture, Marxist-influenced discussions seek to expose ways in which artworks subtly reflect dominant cultural views. These discussions often explore the ways in which dominant views are embedded in the art produced by a culture and function to maintain inequitable social relations in light of such areas as economic class, race, and gender. Marxist-influenced

positions recognize that art can be intentionally produced to change social conditions and challenge dominant views. Art can be used not only to highlight problems or inequities in society, but also to provide a way of thinking and behaving that will eliminate the problems or inequities and ultimately change the world for the better.

Feminist world views also have implications for what constitutes good art. Here again, the focus is on art's function in society and how it promotes the dominant views of gender differences and relationships. From a feminist perspective, art can be used to highlight gender-related inequities and to provide the viewer with an alternative way of understanding the world—a way devoid of discrimination based on gender.

Not all Instrumentalist theories are tied to ideological positions such as Marxism or feminism. Generally, an Instrumentalist view is one that sees the *message* of an artwork as its most significant aspect, and the value of art as its capacity to change the way people think, believe, or behave. An Instrumentalist view is also assumed in making judgments according to the way a particular artwork *practically* functions. An Instrumentalist would argue, for instance, that a chair is good because it is comfortable or can hold an appropriate amount of weight. By contrast, a Formalist might value the chair because it exemplifies an attractive color scheme, and an Expressionist might say that the chair is valuable or significant because it conveys a feeling of warmth.

The student who commented that the significance of the Elvis painting is to keep Elvis' memory alive has also referred to the way an artwork functions. However, the significance is placed in the broader context of social history, rather than its comfort and use in the here and now. Instrumentalist

"To say that a work of art is good, but incomprehensible to the majority of men, is the same as saying of some kind of food that it is very good but that most people can't eat it."
—Leo Tolstoy, Russian novelist and philosopher, 1898

"Progressive art can assist people to learn not only about the objective forces at work in the society in which they live, but also about the intensely social character of their interior lives. Ultimately, it can propel people toward social emancipation."
—Angela Davis, American political activist, 1984

"In a decaying society, art, if it is truthful, must also reflect decay. And unless it wants to break faith with its social function, art must show the world as changeable. And help to change it."
—Ernst Fischer, Austrian editor, poet, and critic, 1959

theories encompass such differences about how and why an artwork has a particular function or use.

This view falls within the broad category of Contextualist theories because it focuses on the work of art in relation to the social, political, and historical context in which it is made, perceived, and used.

Institutionalist Theories

Focusing upon the social context in which artworks are created, perceived, and used, some philosophers have proposed that art can be defined by the way in which objects or events are treated in society. Here, the focus is not upon the characteristics of the object or event itself; nor is it on an artwork's expressive potential. Rather, attention is paid to the social practices accompanying it. The philosopher, Arthur Danto, coined the word "artworld" to suggest the community in which members are involved with creating, curating, collecting, selling, studying, and writing about artworks. Another philosopher, George Dickie, claimed that something is a work of art when artworld members put forward certain objects to be perceived, interpreted, and judged as works of art. Other philosophers have questioned and refined certain aspects of the theory since it was first proposed. Institutionalist theories hold that appreciation and interpretation of objects deemed art by members of the artworld is different from appreciation and interpretation of objects that have not been designated as art. When we encounter objects in artworld contexts such as museums and galleries, we treat them differently from how we might treat them in ordinary contexts.

Institutionalist theories do not provide standards for judging the significance of artworks; rather, they attempt to explain how it is that certain objects (or events) come to be called art.

Linguistic Theories

Some theoreticians consider art a special kind of language. We learn to speak and understand ordinary language through social interaction. Languages consist of systems of symbols that are learned, along with rules for their use. When we know the language, or symbol system, we can understand what is being said. Artworks, according to linguistic theories, can be understood to the extent that one is familiar with the appropriate language or symbol system. Just as there are language "communities" in which sentences are "read" or understood by members of a community, there are aesthetic language communities in which aesthetic objects can be "read." When we consider artworks as embodying symbol systems, we can better understand why we have difficulty reading or understanding aesthetic objects created in cultures other than our own. E.H. Gombrich and Nelson Goodman are two important thinkers who have considered the complex relationship between art and language. Although their explanations differ, they and others who have explored this relationship nonetheless assume that the ability to understand the meanings of artworks is inextricably linked to social context.

Another perspective on art and language use is what has been called the "open concept" perspective. Attending to the way in which the term *art* is used within our language community, the philosopher Morris Weitz maintained in the 1950s that it is impossible to define the term. Because we ordinarily use the term *art* to designate objects or events that have widely different characteristics, we cannot offer a final list of conditions that must be present in order to appropriately use the term. Considering that what is presented and accepted as art is consistently changing, Weitz suggested that the term *art* is what he called an "open concept." He proposed

that theories of art, while inadequate as definitions, can provide useful perspectives from which to consider and appreciate artworks we encounter. Weitz and others who have explored his view have not offered a theory of art in the traditional sense. The "open concept" view is presented here because it draws upon our understanding of art in its social context; specifically, in the context of language use. Furthermore, Weitz's position that art cannot be defined served as an important departure point for the views of many later philosophers in this century, including those of Dickie and Danto mentioned above.

Theories that link art to language do not provide standards for judging the merits of artworks. The focus, again, is upon understanding how it is that we can express and interpret meaning in art.

Imitation Theories

"This painting of Elvis is great! It's hard to believe that it's a painting, because it looks just like him—almost as if it were a photograph."

One of the oldest theories about art is one that assumes that art is a kind of imitation of the world. Plato assumed this when he criticized art, saying it is *merely* an imitation of the world and, as such, was less than the real thing and unnecessary at best. Other philosophers have extolled the value of art for showing us pieces of the world that might otherwise go unnoticed. Philosophical discussions have centered on how an artwork can mirror reality, and have included terms such as "representation" to explain the phenomenon, claiming that artists "re-present" reality through a variety of media, selecting certain aspects of the world to emphasize and hold our attention.

The student who valued the Elvis painting did so because it looked real. Realism is a style in art often

The Haida word for mask is niijanguu, *which means "to copy." So when I make a mask, it's actually copying an image or an idea from the spirit world. I believe that we're connected to the supernatural or spirit world through our minds. When I create a new mask or dance or image, I'm a medium to transmit those images from the spirit world . . . Masks also help to bring you into a particular state of mind. They are objects of the images that we carry around in our minds, and the masked dances are re-enactments of our dreams and memories.[4]*
—Robert Davidson, wood carver and sculptor

2.2 *Robert Davidson,* Dogfish Mother Mask, *1988. Red cedar, copper, human hair, shells, 32 x 22 1/2 x 15"* (82 x 57.2 x 38 cm). *Photo: Ulli Steltzer.*

associated with imitation theories. Many people, including a large proportion of our students, tend to judge art according to standards of realism. For instance, a moviegoer talks about how a film does or does not correspond to the real world. Similarly, paintings and sculpture are often judged by how realistically they portray the subject matter, and the artist is thought to be "talented" to the extent that she or he can draw or paint things as they appear.

Imitation theories can also accommodate art that is not realistic. However, much depends on what counts as "real." If the world and our experience of

it is seen as spiritual, then a work of art that shows this spirituality can be judged as significant, using imitationist assumptions. On the other hand, Impressionistic painting also might be said to present the real world—the real world of light and color.

The psychoanalytic perspective might also be included in the category of Imitationist theories. Governing this way of thinking about art is the belief that all behavior is significant, as artworks are considered in terms of the underlying psycho-sexual-social contexts in which they have been produced. Psychoanalytic perspectives can be traced to Freud,

who investigated the life and work of Leonardo da Vinci in an attempt to identify the fears and anxieties that he believed explained Leonardo's behavior and, ultimately, his art. From this perspective, the artist's biography is the focus of investigation, and the artworks produced serve to suggest and reinforce findings about the artist's psyche. Psychoanalytic perspectives can be categorized here because these findings constitute the "world" that is mirrored in the art produced.

Which Theory Is True?

This question often comes up when an artwork is understood and appreciated from different perspectives. Understandably, most people want to know the "truth." Unfortunately, the answer is complicated and can be related to broad philosophical ways of viewing the world in general, and the notion of truth in specific. Discussing the theories that might be presented addressing philosophical questions about art is not so much to provide a final, "true" answer to "What is art?" and "What are artworks?," but to provide ways in which these questions have been answered by others. The perspectives are offered to help teachers provide their students with general ways of addressing and thinking critically about aesthetic issues. Students can be helped to "try on" different views as a way of reflecting on, clarifying, and refining their own ideas. In attempts to understand art from cultures other than their own, they can explore the beliefs about art that inform the making and responding to art in those cultural groups, using these general categories as points of entry into their investigations.

Donald Kuspit, an art historian, philosopher, and critic, often considers art from a psychoanalytic perspective. In a 1991 article in which he analyzes activist art, which escalated in the 1980s, he talks about the "moralizing artist" as an artist who is interested in the moral message of an artwork—to the exclusion of concern for its aesthetic properties. He discusses Freud's notion of the superego as a way of introducing his analysis of the moralizing artist.

By identifying with an adult important to him, the child acquires a sense of authority and status that makes him feel self-important. He feels guilty and worthless . . . when his superego turns on him for acting in a way his parent would not approve. This includes ways that would directly threaten the parent's authority and status, in effect dethroning the parent. One might note that . . . an artist's overt attempt to overthrow and oust the [artistic] style of his parent artist figures—is one such way.

The moralizing artist, by way of his opposition to existing society and aesthetically oriented art, reenacts the process of superego formation. For society is the parent of us all and aesthetically oriented art is the parent of every artist . . . [T]he moralizing artist identifies with an existing society and aesthetically oriented art he experiences as bad, even irreparably bad, so that their authority and status are rejected . . . [T]he moralizing artist feels guilty because of his negative attitude toward the world.[5]

Philosophical Pluralism

Throughout history, certain theories of art seemed to be consistent with the way people generally viewed the world. What has been considered art during different periods of history has also been more or less consistent with these broad views. For many reasons, today's world is a pluralistic one in which numerous world views can be identified, even within North American culture. Not surprisingly, the range of what we call *art* reflects this pluralism both in the way it looks and in the reasons for its creation. Consistent with a pluralistic society is the view that art can be different things, have different purposes, and be governed by a range of aesthetic standards. Accordingly, another way of answering the question "What is art?" assumes a pluralistic stance. Art is and can be any number of things. For the pluralist, an artwork can be reasonably judged by different standards, reflecting different theories of art, depending on the circumstances under which it is made, viewed, and/or considered. For instance, the pluralist would not have a problem with considering the Elvis painting from all the perspectives outlined above. Indeed, appreciation of the painting is enhanced when it is considered from these various viewpoints. The emphasis is not on "truth" or being "right," but is directed toward gaining the fullest understanding of artworks.

Another form of pluralism is based on the recognition that in our culturally diverse world, art means different things to different cultural groups. The pluralist would seek to understand the uses, principles, and standards governing the creation of and response to artworks within the culture in which they are produced.

Recognizing Philosophical Questions

To plan for philosophical discussions, both teachers and students need to be able to distinguish philosophical from other kinds of questions. Teachers also need to be able to identify philosophical questions relevant to the rest of the curriculum and to the students' interests and needs.

Students routinely ask questions during the course of an art class. Not all of their questions are philosophical; some are practical ones that have to do with moving effectively, efficiently, or appropriately through a planned activity. Some of their questions are about artists and artworks, questions that can be addressed by providing information or showing where the information can be found.

The General-vs.-Particular Distinction

A useful way to think about philosophical questions is to think of them as being about things in general, rather than about *particular* things. A discussion about the meaning or significance of a particular artwork may lead to discussions about general criteria for judging artworks. In this case, because the focus is temporarily away from the artwork in question and is instead on general notions of art, the ensuing discussion will be a philosophical one. One reason that general philosophical questions are so interesting is that they are interwoven with or just below the surface of much of our involvement with art, whether it be in creating or responding to it.

The Ways-to-Answer Distinction

Another way to distinguish among types of questions is to consider the way in which we go about answering them. While it makes sense to spend time discussing or arguing about the answers to some types of questions in a philosophical dialogue, it makes no sense to do so with others.

Questions of Fact

It makes little sense to argue about questions of fact. A question of fact, or an empirical question, requires observation or measurement in order to arrive at an answer. When we consider artworks, we often raise questions of fact. We may want to know who made the artwork or when it was created. We may wish to know how the work was originally used, or how the people who first saw it responded to it. While considering philosophical theories, we might want to know what a particular theorist had to say about a topic. To get the information, we might need to do research. Students can do research to address questions about the origins or data associated with particular artworks. This research may indeed take time and may result in conflicting answers to the original questions, but the question remains a question of fact, requiring the collection of data. Even this distinction is questionable, however, because we might argue that there is no such thing as a purely factual question, a question that does not involve subjectivity or bias both in asking the question and in selecting those things that count as data to be collected. Despite the degree of difficulty in finding answers to questions of fact, and despite some philosophical disagreement about the possibility of facts and factual questions, generally speaking, when a questioner essentially seeks information of some sort, the question typically need not prompt philosophical discussion.

Questions of Interpretation

Interpretation is so central a human activity that we rarely even think about it. We encounter our world through our senses, collecting and interpreting sensory data along the way. Much of our activity is habitual, formed through repeated encounters with and interpretations of similar information. It is when our senses

"Yes, madam, Nature is creeping up."
—James McNeill Whistler, American artist
(to a woman who said a landscape view
reminded her of his work)

"Art is always ultimately about reality.
Or at all events the interpretation
of what can be regarded as real."
—Wolfgang Gafgen, German artist

2.3 Students can consider general questions about objects they encounter, comparing them to artworks they have seen. Photo: Jeffrey Dietrich

2.4 To think carefully about their art-related beliefs, students need to be given time and sometimes a series of questions to consider. Photo: Karen Shriner.

encounter new information that we might be aware of how we are interpreting it. We ask "What does this *mean*?" and respond accordingly. In our encounters with artworks, we also ask about meaning: What is the work about? What does it mean? We need to collect data available to us in the work and in the context surrounding it.

Interpretation is the activity of constructing an *explanation* for the data. We need imagination to take the information available to us and use it, along with our prior knowledge, to construct an interpretation of a work of art. While the process of addressing questions of meaning or interpretation is complex, sometimes difficult, and often time-consuming, and it sometimes leads to philosophical questions, it does not in itself involve philosophical inquiry.

Questions of Value, Questions of Concept, and Metaphysical Questions

In attempts to answer questions of fact and of interpretation, we sometimes ask about the *best means* of doing so. We might want to know the best means of determining the origin of an artwork, or the best means of constructing an interpretation. We would thereby be entering the realm of philosophical inquiry because we would once again be considering methodology in *general* terms. In cases seeking the best means of doing something, we would be addressing questions of value; in this case, questions of *practical* value. We might also raise and address questions of *moral* value ("Is copying someone else's artwork wrong?") or *aesthetic* value ("Is that artwork good?"). To answer all questions of value, we must make a judgment. We judge one procedure to have more (practical) value than another; we judge a particular action to be (morally) wrong, and we judge a particular artwork to have (aesthetic) value. Judgments are based on such things as standards, rules, principles, or criteria, which are often grounded

in broader philosophical beliefs or theories; thus, a question of value leading to a judgment may well prompt philosophical discussion about beliefs or theories assumed in making the judgment. Some questions of value are general ("Are experiences with artworks worth having?") and, as such, require philosophical inquiry to address them.

Questions of concept are those about the appropriate use of terms. When we ask "What is art?," we are asking about the conditions that should exist in order to use the term "art" appropriately. In aesthetics, questions of concept arise when we ask such questions as "What is sculpture?" or "What is a poem?" An immediate response might be to refer to the dictionary. Unfortunately, dictionary definitions of important terms in aesthetics are far too simplistic and invariably prompt further questions. We already have seen that there is no simple answer to "What is art?" To address this question of concept, as with many others, we must engage in philosophical inquiry.

Theories of art are often grounded in beliefs about reality, human nature, and knowledge—beliefs about things beyond the particular physical characteristics of the material world. Questions about these beliefs are "meta" (meaning "above") "physical," and they address fundamental issues: What is life? What does it mean to be human? What is real? What is true? What is knowledge? Many discussions about art ultimately rest on these pressing metaphysical questions. To participate in philosophical inquiry, we do not always consider metaphysical questions. However, they sometimes do emerge during philosophical discussions about art, and it is important to recognize them.

When we ask general questions of value, questions of concept, and metaphysical questions, we are asking philosophical questions. These questions are distinctively different from those of fact and of interpretation in terms of the ways in which we try to answer them. As is evident when exploring the range of theoretical responses that have been offered, philosophical questions rarely have easy answers, but they do promise valuable exchanges as we attempt to address them.

Notes

1 Jennifer Heath, excerpted from *Black Velvet: The Art We Love to Hate* (San Francisco: Pomegranate Artbooks), 1994.

2 The student responses to the Elvis painting are based on a discussion held with undergraduates in an art criticism class taught by the author.

3 Unless otherwise noted, all quotations in this chapter are cited from one of the following references: *The Columbia Dictionary of Quotations* (New York: Columbia University Press, 1993); and Jonathon Green, *Morrow's International Dictionary of Contemporary Quotations* (New York: William Morrow and Company, Inc., 1982).

4 Quoted in Paula A. Baxter, review of *Eagle Transforming: The Art of Robert Davidson*, by Robert Davidson and Ulli Steltzer, *Library Journal* 119 (November 1994): 76.

5 "Art and the Moral Imperative: Analyzing Activist Art," *New Art Examiner*, January 1991, 18–25.

Wonder, Inquiry, and the Philosophical Dialogue

Because children have beliefs about art and often raise philosophical questions about art and their experiences with it, they need an environment in which such questions are encouraged. Then, through classroom dialogue, students can discuss their beliefs and try to answer their questions. This chapter provides suggestions for taking advantage of unexpected moments when philosophical issues are raised, and for assisting teachers in planning for student engagement in philosophical dialogues.

Creating a Climate for Philosophical Inquiry

Teachers generally want their artrooms to be safe places—places where students feel comfortable sharing their ideas, concerns, fears, and dreams. Students need to know that they are valued, that what they have to say will be heard. They need to trust that they will not be put down by their peers. If students are to feel comfortable raising philosophical questions about art, the artroom must be such that they know their ideas are valued. They need to know that they are free to voice their concerns and their beliefs—that their opinions *matter*.

Most teachers know that when students are worried about being accepted by their peers, concerned about problems in their families, or troubled by their studies, they are less likely to be ready to learn. Philosophical inquiry cannot easily take place in an environment in which students are distracted by these issues. However, the environment must be more than a warm, safe place. It must also be a place where inquiry is encouraged and where wonder and curiosity are valued. These aspects not only need to be valued, but they also need to be modeled. Teachers who want their students to ask questions must be willing to ask questions themselves. The teacher must assume the role of fellow inquirer, someone who is curious, who at times stands in awe of the world—someone who shares with students that sense of wonder that is at the root of all learning.

Breaking away from the role of one who has most of the answers is not easy for teachers. It means shifting away from the experience of our own schooling, where the teacher knew the answers and we saw the teacher as one who imparts truth. In many cases, it means forgetting much of how we

3.1 Beverly Buchanan, The Fence and 4 Shacks, *1991.*
Oil pastel on paper, 38 1/2 x 60" (98 x 152 cm).
Collection of Dr. and Mrs. Harold Steinbaum. Courtesy
Steinbaum Krauss Gallery, New York City.
© Beverly Buchanan.

were taught. It means being willing to be vulnerable, to admit to not having all the answers when there is a degree of comfort in viewing oneself as the authority. This takes confidence, and it takes commitment to the belief that students learn best when they are addressing questions that stem from their own experiences.

Including philosophical inquiry in the classroom has its rewards for teachers. They experience the rewards of collaboration as their students provide new perspectives and fresh ideas for consideration. They also get to know their students in new and different ways because through such inquiry, students reveal sides of themselves otherwise only rarely shown. Teachers can observe as their students listen and respond to opinions of their peers.

To experience these and other rewards from participation in philosophical inquiry, teachers and their students need to develop trust in the *process* of inquiry. There is no constant linear path to new insight. Inquiry often moves in starts and stops, meeting straightaways, winding roads, and occasional dead ends. Philosophical conversations might be plodding or accelerated, and yet the quality of philosophical inquiry is not measured in terms of its pace. Short discussions may well result in deep and lasting insights, and extended discussions may consist of a mere rehashing of old ideas. Teachers accustomed to planning certain amounts of time for each lesson component will need to balance this practice with sometimes allowing more than the allotted time for an activity in which students are participating in philosophical inquiry. In other instances, ending the activity and moving on to another will make good sense. Flexibility, then, is important. Patience is another quality important to the inquiry process. For example, just when a discussion seems to be nearing a lackluster end, someone in the group will contribute a question or an idea that captures the imag-

 Letters to Beverly Buchanan

High-school students in an American-studies class studied the work of Beverly Buchanan. They visited a local gallery where her work was exhibited. During an interdisciplinary unit in which the students considered the history, literature, and music of the rural South, they were encouraged to think about how their views were changed, if at all, by seriously considering Buchanan's work. They wrote to the artist, and in their letters, many of the students talked about their evolving definitions of art. Following are excerpts from some of their letters.[1]

"I figured if a toddler could make something like that, does that make them an artist? What I did not know was what these pictures really were . . . I learned art is not just about what something looks like, but more what it means."
—Laura

"I have to admit when we first looked at your paintings of the shacks, I found them hard to fit my definition of art. I was narrow-minded in thinking art was only beautiful and only depicted the pretty and prosperous side of life."
—Ben

"Art isn't just what lies on the outside, but it can rather mean so much more when you know the background or story behind each work and the works as a whole."
—Leisa

"I developed my own belief about art from seeing your exhibition . . . I now believe that art can be anything. Its value is determined by the audience. Anything that is truly valuable will touch a viewer's heart, mind, and soul."
—Amy

"My initial response was that this cannot be considered great art. This was mainly because I was living under the impression that older Renaissance-type art was what art was."
—Thomas

ination of the group members. Patience in the presence of silence, when no one seems to have anything to add, is often rewarded.

Trust in the process of philosophical inquiry comes as teachers and students increasingly experience the rewards of such inquiry. There is no better way to develop this trust than to get started and stay with it for some time. Over time, teachers begin to think of addressing philosophical issues through dialogue as a routine classroom activity. They are ready to address philosophical questions when they happen to come up during the day-to-day teaching of art, and they plan ahead and set aside time to consider relevant philosophical issues.

The Dialogue as the Cornerstone of Philosophical Inquiry

The nature of dialogue could be described as one person's conclusions becoming another person's questions. As philosophers have addressed the views of one another about art over time, they have entered into what might be considered an *extended* dialogue. Brought forward by interesting philosophical questions, the dialogue is the central activity of philosophical inquiry, whether in the past or in the here and now.

We ordinarily think of dialogue as an oral give and take between two people, but a dialogue also might involve more than two people. An entire class or groups of students, for example, might have an open, oral dialogue. In addition, a dialogue might well be conducted in written form. For instance, many teachers have their students keep journals in which fellow students, teachers, and others respond to what the journal writer has stated. A class might begin the year with a question that holds the interest of the students and prompts a series of exchanges that extend the dialogue throughout the year. A dialogue might be held with oneself, as the individual

raises questions, addresses them, reconsiders positions, raises more questions, and addresses them alone.

Guidelines for Group Dialogues
Because of the nature of philosophical inquiry, there simply is no one way in which a philosophical dialogue should proceed. What follows, however, are some general guidelines for facilitating and participating in dialogues.

Guidelines for Facilitators
When philosophical discussions are held in the context of large or small groups, a discussion facilitator should be designated. Initially, this will probably be the teacher.

The facilitator keeps the discussion centered on the issues in question, tries to get everyone to participate, raises questions for the group to consider, and summarizes the points that have been made. When appropriate, the facilitator asks students to clarify their positions and helps them identify assumptions underlying their views. At times, the facilitator relates student positions to those in traditional aesthetic theory. Generally, however, the facilitator raises questions and does not provide answers.

The facilitator helps establish a nonthreatening environment by reinforcing student attempts, asking members of the group to agree with or add to the views presented by others. During the discussion, the facilitator helps students learn the necessity of supporting their positions. When students agree or disagree with a view proposed by another member of the group, the facilitator encourages them to state their reasons carefully. The facilitator should also encourage students to offer alternative views for the group to consider. When positions taken are very different from one another, the facilitator should summarize them at various times during and toward the end of the discussion. The facilitator is

responsible for determining when moving away from the original question might be appropriate.

An important part of facilitating a group discussion is providing closure. Even when the time set aside does not allow for a natural end to the discussion, the facilitator should help participants summarize the points made and the different positions that have emerged. The facilitator can also help students understand that there are times when it is reasonable to agree and to disagree—that some issues cannot be resolved, because there are deeply held beliefs that are not likely to change. The facilitator should emphasize that dialogues can result in a change of opinions. However, if the opinions are not changed, the facilitator can help participants be more aware of the reasons for maintaining them.

In following these guidelines and modeling good reasoning skills, the facilitator helps the participants learn behaviors that will enhance their abilities to think critically. As students become more adept in dialogue, they can take turns functioning in the role of facilitator.

Guidelines for Participants

Initially, participants in the dialogue need to respect two rules: they must give reasons for their views, and they must try to respond to what others have said. Again, as they learn through practice what kinds of behaviors lead to valuable dialogues, they can add to these rules as they believe appropriate.

Addressing Student Questions

Imagine a scenario in which a teacher and students are discussing a reproduction of a work of art by Kandinsky. Kandinsky's paintings are deceptively simple, and students often wonder why they are considered art. Almost immediately, some of the students begin to snicker, claiming that something

Dialogue Within a Journal
(high-school art student and teacher)[2]

Teacher's question: Is it important for the artist to create "original" work? Why/why not?

Student's response: Yes. Art is not really art to me unless it is original. Taking pictures of already-made photographs is art, but it's close to not being so. It is one instance where you really need to know WHY that lady did it. Originality, to me, is part of the definition of art; therefore, art without originality is nothing to me but a copy of someone else's imagination—making the "copyists" unimaginative . . . and it's plagiarism!

Teacher's question: How do you know if it is original or influenced by something else?

Student's response: You should be able to just tell . . . how phony the emotion is expressed, etc. And recognize certain influences from others.

that looks like this painting ought not be called art; that just about anybody could paint a painting like this by slapping different colors of paint around the canvas. After all, they say, isn't art supposed to look like something? In this case, the teacher has several options.

Option 1
Ignore the issues.

This is probably the strategy of choice for more teachers than we want to think about. There are probably times when there is a good educational reason for ignoring philosophical concerns raised by students, but it is hard to take this as a serious option.

Option 2
Tell the students that they'll understand all about it when they get older and have perhaps taken art-history classes.

Again, while many a parent or teacher has chosen this strategy, it clearly runs counter to attempts to establish an environment in which questioning is valued.

Option 3
Give the answer.

A teacher might simply draw on his or her own experience and beliefs and tell the students why this object is considered art. Unfortunately, far too many teachers think that this is the only option, thereby depriving their students of the opportunity to do their own hard thinking about issues of importance to them. While there are probably times when it is appropriate for a teacher to share her or his values or beliefs with students, this ought to follow serious consideration of the consequences.

Option 4
Provide students with the opportunity to discuss the question on an impromptu basis.

The advantage of this option is that it allows the students to know that their questions are valued and that it is appropriate to raise questions when they are puzzled. In addition, it provides them with the opportunity to think and talk about something that is genuinely intriguing to them.

Whenever the art curriculum is designed to have students actively participating in art criticism, art-making, and art-historical inquiry, students are likely to raise some questions that are essentially philosophical. At this point, the teacher must consider the options and decide how to address the questions. While opting to stop everything immediately and allow time to address philosophical questions as they arise has a great deal to be said for it, there are clearly disadvantages.

Teachers do *plan* their lessons, and art teachers especially are tied to certain time constraints, with a set amount of time for a weekly art lesson with a particular group of students. In addition, because these kinds of questions come up at all different times—as students are working on their own studio projects, when there are only a few minutes left for the class period, or when the point of the lesson is far removed from philosophical inquiry, for example—it does not always make sense to address questions at the time the students raise them.

Option 5
Save it until later.

Rather than ignoring the question or giving a short and all-too-easy answer, teachers can at least support curious students by saying that while the time is not appropriate now to discuss the matter, it certainly is important to think about these things and that there will be time set aside in the art class to pursue them later.

A Big-Questions Chart

Teachers might address the problem of timing by instituting a big-questions chart. Questions raised by students are recorded on a chart, poster, or bulletin board on view in the room and set aside for this purpose. The chart functions as a reminder that there are "big" questions about art, questions raised in the process of making art and thinking about it. Students can add to the chart, and time can be set aside to address one or more of the questions in small or large groups. Although the students may never address all the questions, they will see that such issues are to be taken seriously, and will be increasingly inclined to raise them and perhaps address them alone or with others outside the artroom. Once again, the key is to create an environment in which students feel free to raise questions, where inquiry is valued, and where the students are thought of as serious learners.

Planning for Philosophical Dialogues

In planning dialogues, teachers need to consider the following points. Each is more thoroughly explored in the remaining chapters of the book.

1 Determine the questions, issues, and topics to be discussed.

Ideally, the questions, issues, and topics to be addressed will already be embedded in the curriculum as part of the unit of study underway. In curriculum planning, teachers can anticipate questions that may arise and include plans for discussion of these, just as they plan for other activities within a unit.

To reinforce the value of raising philosophical questions in the classroom, a teacher may refer to the big-questions chart and choose a question or questions relevant to the unit of study. A teacher might invite the students to assist in choosing ques-

Journal Entries

(high-school students)[3]

"When I first began creating art, I did not want my works to be appealing; I wanted them to show how I felt. However, I soon learned that I cannot effectively communicate my feelings through my art if it is presented in a way that is distracting to the eye. This tends to cause the audience to become lost in the work's message."
—Ryan

"Art is something that, no matter where I go or what career I choose, will always be a substantial aspect of my life. To me, it is not whether other people like my art—I don't create it for them—it only matters that what I create is something that comes from inside me, whether it be a political opinion or a way to find solace after a wearying day."
—Alexis

Try This

When planning dialogues, consider:

- The questions, issues, and topics to be discussed

- The way in which the questions, issues, and topics will be presented to the students

- The class configuration

- The particular skills to be practiced during the dialogue

- The lesson outcomes

- How student learning will be assessed

**Discussion Point:
Is a Telephone Book an
Artwork?**

In 1989, the artist David Hockney was
asked by the telephone company in the
city of his birth in England to paint his
hometown and the Yorkshire country-
side for the cover of its directory. He
agreed and did not accept payment.
Normally, his artworks sell for more than
two million dollars. People have been
collecting the telephone books (one per-
son bought 500 copies).

- Why would someone want to collect
 these phone books?

- Would the entire book be important,
 or just the cover?

3.2 David Hockney, Bradford and District *(cover art
used on the Bradford Telephone Book), 1989. Color
laser copy, acrylic, crayon, uni-paint marker, uni-ball
pen, 7 x 7 7/8" (18 x 20 cm). © David Hockney. Photo:
Richard Schmidt.*

tions from the chart or from their journals. Their
ability to make such selections depends on their
experience with philosophical dialogues.

There are times when a teacher may plan for a
philosophical dialogue about questions or issues not
directly related to the unit of study but that are
nonetheless relevant to the overall curriculum.
Current events within the community, for example,
often provide opportunities for students to explore
their beliefs about art and to practice good thinking
skills through dialogues. If a community is troubled
by an installation of a work of public sculpture, for
example, a teacher might ask students to discuss the
issues. Community issues can rarely be anticipated
and will not fit within a unit of study in every case.
The teacher will need to make a judgment about use
of time for such a discussion.

Teachers can build a file of questions, issues, and
topics for philosophical dialogues and refer to it in
planning. Newspapers, artworld magazines and jour-
nals, lesson plans from the Internet, and teaching
magazines are good sources for philosophical issues
of interest to students. As students become accus-
tomed to thinking and talking about philosophical
questions, they will begin to bring items for discus-
sion to class. The creation of the file can become a
class endeavor. Periodically, topics or questions from
the file might be put on view in the classroom for a
period of time, and dialogues can then be planned
around them.

**2 Determine the way in which the questions, issues,
and topics will be presented to the students.**
Teachers can draw on what they know about moti-
vating students and design a range of strategies to
engage them in philosophical thinking and talking.
For instance, real or imaginary stories might provide
issues to discuss. Debate formats and role-playing
exercises get students to explore their beliefs and

those of others. Again, as teachers become accustomed to having students take part in philosophical inquiry, they will feel increasingly more comfortable in designing imaginative strategies.

A teacher may wish to establish desired results from a group discussion. For example, students can be asked to summarize the discussion in terms of the major positions taken. Students might record the number of those who agree with the various positions related to an issue. Students might be asked to keep a record of the questions that need to be answered in order to move toward agreement. They might be asked to record their opinions before moving forward in a dialogue about an issue and then record their views as the dialogue comes to an end, noting the extent to which their opinions have been changed.

Students might record their thoughts about the discussion. They might state what questions they have for particular group members, or they might write a brief letter to another group member, stating the extent to which they agree or disagree with the views of that person. If the discussion is about a community issue, students might compose letters to the editor in which they express their views, views that have been clarified and/or changed during the course of the dialogue.

3 Plan the class configuration.

How a class will be configured will depend in part on the way in which philosophical issues will be presented, as discussed above. A dialogue may be planned for the entire class, in which case a teacher will need to make all students feel as though they are members of the group. Students seated with backs turned toward the facilitator, for example, will be less compelled to enter the discussion than students who have a clear view of the facilitator and the rest of the class. This may mean moving and regrouping

3.3 As they see evidence of creative effort in their own communities, students can ponder the question, "Why do people make things?" William Fox, Scarecrows, *1997. Kutztown, PA. Photo: Katherine Stewart.*

tables and chairs. Any kind of classroom discussion can be sabotaged by a few students seated at the periphery, who do not sense that they are contributing members of the group.

Collaborative learning has become standard practice in many schools, and configuration strategies associated with this approach can be implemented for philosophical dialogues.

4 Identify the particular skills to be practiced during the dialogue.

The development of students' critical-thinking skills can be enhanced through philosophical inquiry. They can learn how to listen carefully to what others say, to state their views carefully, and to provide reasons for what they believe. They can learn to use words carefully, make distinctions, uncover assumptions embedded in their own and others' statements, and offer cogent arguments for their positions. During dialogues, these skills can be emphasized and explicitly reinforced.

If, for example, students need practice in listening carefully, the facilitator might require them to summarize the position to which they are responding before making their own view known to the group. A more advanced skill is the ability to uncover assumptions. Gamelike strategies, depending on grade level, might be designed. Students might be given the responsibility of noting any time a participant uncovers an assumption. A point system is implemented, such that any time an assumption is uncovered, a student receives a point. Accumulation of a certain number of points is rewarded with the title of "assumption finder." Students should be aware beforehand of the skill to be practiced in a particular discussion so that they can actively participate in developing or practicing the skill. This practice can be augmented by special activities designed for this purpose and addressed outside of philosophi-cal discussions. The development and refinement of critical-thinking skills can be a focus for art teachers and classroom teachers working together.

5 Align the activity with the lesson outcomes.

Probably one of the most important questions a teacher can ask during teaching is "What's the *point*?" Every activity should be aligned with outcomes desired for a particular lesson, unit, or program; and a teacher should be able to identify at any time, the outcome toward which a teaching strategy is aimed. Philosophical dialogues need to be planned in light of outcomes. These might be stated generally, such as "The student will know that there are general questions about the nature of art and artworks;" or they might be stated specifically, such as "The student will be able to formulate a definition of sculpture and support this with reasons." Students too need to be aware of desired outcomes so that they can be involved in the assessment of their own learning.

3.4 Middle- and high-school students discuss baskets with different histories—some machine made, some handmade and some made with nontraditional materials—and record the questions they have as they do so. Photo: Jeffrey Dietrich.

6 Determine how student learning will be assessed. Many times, the activity designed for philosophical inquiry will function as the activity in which student learning is assessed. At other times, the teacher may design specific tasks for assessment. These might be planned to follow a dialogue activity immediately or in the future. When teachers are clear about the desired outcomes for a particular activity, they need only to ask themselves how they will know that the students have learned what they *intend* them to learn in order to design strategies for assessment.

When teachers and students view themselves as fellow inquirers, philosophical questions flow freely within and throughout student involvement with art. These questions become the springboard for philosophical dialogues—whether they are held spontaneously as questions are raised, or planned for within units and lessons of study. While taking part in dialogues, a facilitator and dialogue participants practice good reasoning as they explore issues for discussion. As teachers plan for philosophical inquiry, they need to consider which and in what ways philosophical issues will be addressed within the curriculum, what students will learn through engagement in philosophical inquiry, and how this learning will be assessed.

3.5 *When considering artworks, students might question whether the materials used and the extent to which they are permanent are important factors.* Snowman. *Kutztown, PA, 1986. Photo: Marilyn Stewart.*

Notes

1 High school students in an interdisciplinary Humanities course at Muhlenberg High School, Laureldale, PA; Caren Cornman, art teacher.
2 High school art student with art teacher Brenda Jones, Wichita East High School, Wichita, KS.
3 High school art students at Wichita East High School, Wichita, KS; Brenda Jones, art teacher.

Chapter

4

Generating Questions for Philosophical Inquiry

Teachers can plan for philosophical inquiry and help students learn to think critically about philosophical issues related to being makers of and responders to art. Refinement of this thinking will enhance students' philosophical engagement.

Planning and the Art Curriculum

In a balanced art curriculum, there are times planned for focus on the content and skills of art-making, art history, and art criticism. There also are times planned for focus on philosophical inquiry and its attendant concepts and skills. As they plan activities for philosophical inquiry, teachers should try to create conditions that mimic those when philosophical questions, issues, and topics arise naturally. In addition, in planning activities for philosophical inquiry, teachers should aim for a conceptual fit within the unit or lesson.

The questions and activities suggested in this chapter are necessarily provided out of context, but may serve as models to be adapted for use in a variety of lessons or units of study.

Determining Questions, Issues, and Topics

In planning activities for philosophical inquiry, teachers need first to determine the philosophical questions, issues, and topics to be considered. This will be more challenging for the novice than for the teacher who has experience with philosophical inquiry and is familiar with the kinds of questions raised by philosophers over time. A teacher will gradually develop the ability to generate philosophical questions by closely examining unit themes, lesson topics, and activities within the units of study. Philosophical issues are often embedded in typical art-program activities and themes. One way to proceed is to review the list of philosophical questions that students have raised at various times and that have been saved for later discussion, considering whether any of the questions have relevance for a particular unit or lesson activity. Also, students' journals may contain questions of relevance to them that might be appropriate for discussion by the entire class in conjunction with a particular unit or lesson.

Teachers might review a list of philosophical questions. Questions stated generally or raised in other contexts might be adapted for the unit or lesson focus. In addition, during the course of planning, as teachers reflect on current events, community issues, and artworks related to the unit of study, they may identify philosophical questions or issues worth exploring.

Unit and Lesson Themes

Philosophical questions may actually function as primary unit organizers. The question "How is art the expression of feeling?" or "In what ways does art represent the world?" could involve students in a range of activities in art criticism, art history, and art-making, as well as philosophical inquiry.

Philosophical questions or issues also might be considered with other themes or topics that often provide the focus for curriculum planning. Such topics might be communities and their art, tradition and innovation, things not always being what they seem, portraits and people, and private expression in public places. In designing a unit on communities and their art, for instance, a teacher might raise philosophical questions about the role of art in society. Students might be asked to consider the degree to which and the ways in which any artwork reflects a society's values and beliefs, whether artworks can move a society toward acceptance of new ideas and values, or whether artists have a moral obligation to society in creating works of art.

The theme of tradition and innovation suggests questions about originality—whether it is possible for *any* work to be original. It also suggests questions about the nature and role of traditions in art-making. Questions about ways in which art represents the world and the view that art is essentially an imitation of the world might be considered in connection with the theme of things not always being what

they seem. The possibilities for and problems associated with creating a portrait might be explored in a unit on portraiture, and questions regarding the possibility of expressing a private self might be raised within a unit focusing on private expression in public places.

Activities Within Other Art Disciplines
In addition to identifying philosophical questions, issues, and topics associated with general themes, teachers can note questions about making art, art-historical inquiry, and art criticism that can be adapted to fit specific, planned activities. Teachers can

examine activities within lessons they have already planned, and extend them to include relevant philosophical questions or issues.

Philosophical Questions and Studio Inquiry
As students produce art, they can consider philosophical questions related to their work. Students are often asked to create fantasy creatures or make-believe worlds. A teacher might plan for students to consider the question "If a painting shows an image of something that never happened, can it still tell us the truth?" For a studio activity in which students create artworks that are in the style of a

4.1 *Paul Chudy,* Paint By Numbers, *1994. Computer graphic (originally appeared in the 14 March 1994 issue of* The Nation*). © Paul Chudy and Komar and Melamid, 1994.*

Discussion Point:

Knowing About Other Artworks

"There is nothing more difficult for a truly creative painter than to paint a rose, because before he can do so he has first to forget all the roses that were ever painted."[1]

—Henri Matisse

- Should truly creative artists be familiar with artworks made by others? If so, how should the artist use this knowledge?

- Is there such a thing as a truly creative artist?

- Should artists "forget" what they know about art made by others? Is this possible?

- Why would an artist want to forget the artworks made by other artists?

- Do you agree with Matisse?

particular artist, a teacher might have the class explore the questions "Is it possible to create a work of art in the style of a particular artist and still have it be your own?" and "What characteristics would a good artwork made in the style of another artist have?"

Students working with a particular art form might be asked to consider its characteristics by such questions as "In what ways is a painting different from a sculpture? A photograph different from a painting?" They also may explore the more general question "What makes one kind of art form different from another?"

When students are involved in their studio work, they sometimes make a preliminary sketch or a small maquette. They might explore whether this preliminary work ought to be considered a part of the artwork ultimately created. If not part of the final work, should they be considered artworks in their own right? After all, artists' sketches are routinely exhibited in museums.

"Should artists always make something that has not been made before?" and "What makes any artwork good?" are questions that students sometimes ask as they create their own artworks. These questions and others may be included for student consideration as teachers extend studio activities to include philosophical inquiry.

Philosophical Questions and Art-Historical Inquiry

Students study art history as they encounter what art historians have said about artists, artworks, and the contexts in which artists were working and artworks were produced. They also sometimes engage in their own art-historical inquiry, attempting to construct their own accounts of artworks and the contexts in which they were made. In each case, students might explore philosophical issues. For instance, in reading

Discussion Point:
Polling About Art[2]

The art team of Vitaly Komar and Alex Melamid sponsored a poll of the American public about their preferences in art. Melamid explains why they wanted to do this.

I just was thinking about how this society works, and how the rulers in this society get in touch with the people, with real American people. How producers get in touch with consumers. In real life they take polls . . . And what the poll tells, supposedly, is majority opinion . . . And in art, we—my partner and I—were brought up with the idea that art belongs to the people, and believe me or not, I still believe in this. I truly believe that the people's art is better than aristocratic art, whatever it is.[3]

Komar and Melamid created a painting based on the information they gathered. It is a landscape that includes lots of water—a lake, a stream—done with lots of blue (America's favorite color), some wild animals, and people at leisure. Brushstrokes were evident, along with soft curves, random patterns, and blended colors.

- Is it a good idea for an artist to find out what people want before making an artwork? Why or why not?

- Do you agree with Melamid that art should be for the people?

- Can art be "for the people" if the people don't like it or understand it? What is the responsibility of the artist to the people?

Below are some of the nearly 100 questions asked of and responses given by 1,001 people.

Which, if any, of the following types of outdoor scenes appeals to you most?

Paintings of the forest	19%
Paintings of lakes, rivers, oceans, and seas	49
Paintings of fields and rural scenes	18
Paintings of the city	3
Paintings of houses, buildings, or other structures	5
None	less than 1%
(All equal/Depends)	5
(Not sure)	1

Which of the following statements is closest to your view?

Paintings should ideally serve some higher goal, such as challenging their viewers to think about art or life in a different way than they do normally.	19%
Paintings don't necessarily have to teach us any lessons, but can just be something a person likes to look at.	75
(Both/Depends)	4
(Not sure)	1

And do you tend to favor paintings with sharp angles or ones with soft curves?

Sharp angles	22%	(Depends)	9
Soft curves	66	(Not sure)	3

In general, do you enjoy paintings that have a more serious or a more festive mood?

Serious	37%	(Depends)	12
Festive	49	(Not sure)	3

historical accounts, students might discover that art historians do not always agree. This realization gives rise to some interesting questions about what we might expect from art historians or what might account for the differences in art-historical information.

Students might explore this even further when they participate in their own art-historical inquiry. For example, two or more students are given the same object—a kitchen implement from the 1950s. Separately, they interview their older family members or other community members about the use of the implement, who might have owned it, and what it replaced from an earlier time. They are encouraged to use resources such as the library and the Internet to determine how the implement is similar to or different from others of its type. When students meet to present their findings, they will likely discover that they have varying accounts. By explaining the differences, they are better prepared to discuss the process of art-historical inquiry, what we can expect from art historians as they provide accounts of artworks, and the extent to which art-historical information is true.

Sometimes, art-historical information gives rise to philosophical questions. For instance, art-historical accounts about Mathew Brady, the noted Civil War photographer, suggest that he often rearranged dead bodies before taking photographs. Similarly,

4.2 Raphael, School of Athens, 1509–11. Fresco. Stanze di Raffaello, Vatican Palace, Vatican State. Courtesy Art Resource.

Edward Curtis, known for his turn-of-the-century photographs of Native Americans, carefully posed his subjects, sometimes having them reenact ceremonies. Students might be asked to consider whether these facts should make a difference in the appreciation of the Brady and Curtis photographs. They might be asked to consider whether their views would be different if the photographers had used painting rather than photography as their medium.

The history of Western art has many examples of group portraits or reports of historical events in which artists included their own images. In *School of Athens*, for example, Raphael included his own image along with the scholars of antiquity. Art history also indicates that Raphael's depiction of Heraclitus in the same fresco is actually a portrait of another artist, Michelangelo. Albrecht Dürer placed himself among other figures in *The Feast of the Rose Garlands*, an image of an enthroned Virgin and child surrounded by other religious and civil leaders of the time. These and other art-historical accounts suggest philosophical questions about the relationship between art and truth, about the artist's responsibility to his or her viewers, and the expectations that viewers have or ought to have with respect to certain kinds of artworks.

Art historians have discovered that some works of art thought to have been created by one artist were actually created by another. These findings become particularly interesting if the actual artist is less well known or less esteemed than the first, or if, when it has been assumed that the artist was a man, it is then discovered that the artist was a woman. How does or should the new information affect our viewing, understanding, and, ultimately, our judgment of the work? If art historians discover that a particular artwork is a forgery, questions might arise about what constitutes a forgery, whether a forgery can be

Discussion Point:
Mona Lisa

In the window of a blood bank in Paris hangs a poster with an image of the *Mona Lisa*. The poster reads, "I too am priceless. Give blood today." This is but one example of the ways in which reproductions of the painting are used for commercial and other purposes. Art historian Andre Chastel wrote that fame has ultimately compromised the essential role of the *Mona Lisa* as a work of art:

This dubious notoriety, popularity, at once laughable and tragic, concerns an object that no longer has anything to do with Leonardo da Vinci . . . She belongs, rather, to the insatiable factory of the media, whose fictions assault celebrities, those figures destined for mass consumption. She is detached from all historical and human reality.[4]

- Do you agree with Andre Chastel that the *Mona Lisa* has essentially changed due to its popularity?

- Do you agree that she is "detached from all historical and human reality"?

more valuable than an original, if a copy is a forgery, and whether copying an artwork is wrong.

Participation in art-historical inquiry prompts questions about the kind of information conveyed through art. For instance, a teacher might ask students to consider how and the extent to which artworks tell viewers about the people who made them or the world in which they are made. A teacher also might ask students to consider the questions "Do the meanings of artworks change over time?," "Do the meanings of artworks change from one place to another?," and "If meanings change over time or from place to place, how does this happen?"

Philosophical Questions and Art Criticism
When students think and talk about the meaning and significance of particular artworks, they often construct different interpretations and judgments of the same work. They can be asked to consider whether there can be more than one plausible interpretation of an artwork. They can discuss standards for determining what counts as a plausible interpretation, or what counts as a reasonable judgment of a work of art. Engagement in art criticism also often results in questions about how much contextual information is necessary to construct a plausible interpretation. Should viewers consider the artist's statement about her or his intended meaning when attempting to interpret a work of art? What if the artist's statement of intent differs from the interpretation of others? Questions about necessary contextual information often arise when students consider works of art from cultures other than their own. Is it possible to construct an interpretation or judge the significance of, say, a ceremonial mask from another culture? Should standards be different for works from different cultures? If so, what would be the appropriate source for such standards?

Students might consider the extent to which their own personal experiences ought to be taken into account as they construct interpretations and make judgments. They might address the questions "How do our beliefs about art influence the ways in which we perceive, interpret, and evaluate artworks?" and "Why might being aware of your beliefs about art be a good idea?" When thinking about their responses to artworks, students might also consider whether it is possible to dislike an artwork and still judge it as having merit or significance, or to like an artwork and judge it negatively.

When students consider artworks that have subject matter offensive to some, they might address questions about censorship: Should we ever censor works of art? Under what conditions? Should we ever destroy an artwork, and if so, under what conditions? Ultimately, students may consider how important it is that everyone agree about whether an artwork has merit.

When teachers think carefully about the unit themes, lessons, and activities they typically plan for their students, they can anticipate questions that might be raised or identify ones that would be appropriate to raise. Teachers who wish to incorporate philosophical inquiry into their curricula and who then need to identify questions, issues, and topics for student consideration might also look to the particular artworks they plan to include as part of a unit or lesson of study.

Artworks
Contemporary artworks that challenge traditional conceptions of art or the traditional materials and techniques used to create art are often troubling to the viewer. Computer-generated images, installations, performance art, earthworks, video art, conceptual art, art on the Internet, and certain public

monuments sometimes challenge our ideas about art. We ask "How can *this* be art?" or "How am I, as a viewer, to encounter and respond to this?" or "Is this work a sculpture? A photograph? A painting?" In attempting to identify philosophical issues, teachers should verbalize their consternation, putting their concerns in the form of a question or a series of questions. If teachers have doubts about artworks, probably their students will as well. When identifying questions for philosophical inquiry about contemporary work, teachers should try to imagine how their students will react to the artwork.

Although traditional artworks may not prompt this kind of concern, philosophical questions can be posed about them. Words like *all, every,* and *always* are worth remembering when generating philosophical issues. With these words, teachers can consider works from different perspectives and as points of entry to generate a range of possible questions, issues, or topics for philosophical inquiry with students.

Considering the Subject Matter

Does the subject matter of the artwork at hand suggest any questions to consider? For instance, if the subject matter is religious, we might ask the general philosophical question "Is there a proper way to depict religious subject matter in works of art?" or "Should *all* artworks with religious subject matter appear in a certain way?" Many examples of Western art depict Christ, the Virgin Mary, and other religious figures as if they were portraits; yet, in most cases, there is no historical record of the actual physical appearance of these individuals. Students may discuss the extent to which this should be considered a problem. Depictions of these same religious figures vary, depending on the culture in which they are produced. Does this matter? What

 In the News: Living Art

Roger Powell, a homeless man in London, was recruited by the artist Tony Kaye to become a real-life art exhibit entitled *Roger at the Tate Gallery*. Roger was on exhibit in front of and inside the Tate from about 11 a.m. until 5 p.m. Roger was free to move around the museum. He said, "I'm here because I'm considered a work of art too. One of the [other] artists here made a chair that everyone can come and sit on. I'm like that—people can come and ask me what it's like to be homeless. I know I'm not the type of art you can hang on the wall, which I'm glad about. I feel I'm more useful than that. As I see it, Tony, who I work for, is the artist, and I'm just his canvas."[5]

Stephen Taylor Woodrow, a performance artist, and other artists were part of an exhibition entitled *The Living Paintings* at the New Museum of Contemporary Art in SoHo. Woodrow, covered with black spray paint, and his two fellow "paintings," one covered with blue and the other with red paint, were attached to harnesses and dangled from canvases hung on the wall. Each living painting portrayed a different mood—one expressed boredom, another looked shy and sad, and the third looked hostile. The "paintings" came to work five days a week during the run of the exhibition.[6]

Student Responses

In what ways are artworks special? What makes some artworks better (or more special) than others?[7]

"Artworks are special because they can show somebody something, they might make people feel like doing something or inspire them . . . Art serves many purposes: to make people feel good, to inspire, to entertain, to amaze, and to fool, as in optical illusions or 3-D pictures . . . "

—Samyra, grade 8

"Art is made special by the thoughts the piece expresses, not by the quality of craftsmanship by the artist. Some art makes people sad, some art makes people happy, but the best art is the art that makes people stop and think about the art's meaning—really good art will have you thinking at any range from days to the rest of your life."

—Jason, grade 8

"All artwork is special in its own way. Some tell you stories, some show moods, and some just pull you into their own little world. I think those are the most interesting . . . "

—Michelle, grade 8

role do these depictions play? When considering subject matter, it is sometimes interesting to note not only what is depicted, but what is missing. For instance, in examining paintings, sculptures, or photographs that ostensibly document historical periods or specific events, we might wonder if there is a group of people who would have been present or involved but are not shown. We might consider the way in which the subject matter is presented. For example, are conditions of war or slavery romanticized? These examples suggest questions about the role of truth and falsity in art. Subject matter might prompt questions about whether depictions of horrific things can ever have value, when what is depicted is something violent or inhumane.

Considering the Types of Art

Suppose that a teacher is planning a unit or lesson in which students will consider a portrait. The teacher might consider what a painted or sculpted portrait is capable of revealing about a person, whether a photograph is not a more accurate way of depicting someone, and whether all photographic portraits necessarily provide more accurate information about the person depicted. A philosophical discussion might be planned in which students are asked to consider whether and in what ways photographic and painted or sculpted portraits provide viewers with the "reality."

Careful looking at a traditional portrait may provide other insights about what is presented. For instance, when considering the dress and demeanor of the individual, the setting in which the person is shown, what objects surround her or him, and what these aspects further symbolize or suggest, a teacher might raise philosophical questions having to do with the role of art in society. Why might someone want to be shown in such a situation, accompanied

by such objects? Should portraits be examined primarily in terms of the message conveyed about an individual's place in society? We know, for example, that what appear to be simple family portraits of people on the Western frontier at the end of the nineteenth century were often posed shots for which the subjects wore borrowed clothes. They sought to portray a higher standard of living than the one they were experiencing. This suggests questions about what kind of information we should have in order to interpret portraits.

As a teacher continues to think about portraits, other questions emerge. Is something a portrait if it does not include depictions of people? Is there a "best way" to create a portrait of a person? What ought to be shown in a portrait? Portraits may attempt to show the psychological "reality" of an individual. Can this kind of reality be represented? These philosophical questions show the kinds of directions that might be taken when considering different types of art.

Considering Experiences
Teachers might reflect on their experiences in perceiving a work of art—how the work affects them, how it provides information, how it makes them think or feel—in order to plan for philosophical questions or issues. When reflecting on such experiences, the teacher might wonder whether an artwork that evokes sadness, for example, can still be considered worth viewing. She or he might also wonder how it is that an artwork can make anyone feel anything.

A teacher might reflect on how perceiving and interpreting artworks is similar to or different from other kinds of experiences. Thoughts about experiences with artworks prompt many questions. Is there

4.3 Philosophical questions often emerge when we think carefully about artworks we encounter. Photo: Karen Shriner.

a "best" way to respond to artworks? Should people respond to artworks by feeling something? Should people respond to artworks by thinking in new or certain ways? Is it ever okay to be uncomfortable with an artwork? If an artwork fails to prompt a certain kind of response, does this mean that the artwork is not good? Does the best way to respond depend on the particular artwork? Are there certain responses that are not appropriate? Is it ever appropriate, for example, to feel sadness, fear, or anger when looking at an artwork?

Considering the Context

In planning for philosophical inquiry, teachers might consider what they have learned about the social-historical context in which an artwork was produced. Some works of art were problematic at the time of their creation. The issues raised at the time might be brought to the students for consideration.

Attention might also be paid to the context in which a work is currently viewed. A wonderful example is the *Mona Lisa*. When we find the image on pasta packages, on billboards advertising alcohol or the latest fashions, and on greeting cards, how does the current context affect its meaning? Anyone who has been to the Louvre can tell about the small images of the *Mona Lisa* posted throughout the museum, with arrows pointing the direction to follow to find the actual painting. In the gallery where it is exhibited, a throng of people face the painting, which is enclosed in bullet-proof glass and flanked by guards who periodically turn on a light so that viewers can actually see the artwork, provided they are well positioned in the crowd. In this case, we might consider the question "Is the meaning of an artwork somehow in the work, or is meaning determined by the context in which it is viewed?"

4.4 Mabel Burkholder created the quilt design Carolina Springtime because tourists asked for patterns that they thought looked more like Pennsylvania "Dutch" designs. Shown here folded over a clothesline, the quilt also has been made longer than traditional quilts to accommodate the contemporary custom of folding the quilt over pillows at the top of the bed. Photo: Katherine Stewart, 1997.

Chapter 4

Our expectations about certain kinds of art also prompt consideration of the context in which a work is produced. Suppose that we are considering a quilt by a contemporary Pennsylvania Mennonite quilt maker. We have certain expectations, probably based on romantic stereotypes: the quilt was made by hand, perhaps in a home without electricity, after farm chores were completed; and it contains patterns associated with Mennonite quilt making over the years. On further investigation, we discover that the pattern is a recent design, created especially for tourists who want to buy quilts with the tulip and bird motifs associated with the Pennsylvania Dutch; and that the actual quilting has been done by a group of women and men in another state. When an artwork was created within a context different from what we had assumed, how does this new information change our original perception of the work or our assessment of its merits?

Considering the Artist

Issues sometimes arise when considering information about the artist or artists of a work. As with the Mennonite quilt, we may discover that the work was created by more than one person, perhaps designed by one person and executed by others. We might wonder who exactly is the artist and whether more than one person can create a single work of art. Contemporary murals are often collaborative projects. Does this raise a problem with our traditional—and Western—ideas about artists? For hundreds of years, the idea of the artist as genius has been prominent. Are artists geniuses? What is a genius? Do we have certain expectations about the way artists are to conduct themselves in their art-making? Can someone make an artwork without knowing it? Some people are referred to as "primitive" or

 Students Consider Sculpture in Their Community

Seventh-grade students examined sculpture placed in a local public park. They had the following to say:[8]

"The good things about it [the sculpture] are that it adds color to the park, it makes people stop and look, it also makes them wonder. The bad thing about this sculpture is that it takes up too much room."
—Natalie, grade 7

"I like it because it shows the pride of Allentown. It's the statue of liberty to the people of Allentown."
—Chad, grade 7

"I personally think it's not appropriate to put these sculptures in public parks where they take away from the natural scenery. If they want to display the sculptures publicly outdoors, they should reserve a special place to display them without having to put them in places where people go to enjoy nature naturally without man's additions."
—Douglas, grade 7

"outsider" artists. What is implied by these designations? To be an artist, must she or he be an "insider?" Do artists necessarily have to have certain feelings to create expressive art? Can a good person create art that shows evil things? Questions like these might emerge when considering the artist as a catalyst for philosophical inquiry.

Current Events as Springboards for Philosophical Inquiry

In planning for philosophical inquiry, teachers might wish to capitalize on issues raised in the local community. A sculpture has been placed in a public place: some people are outraged, and others are pleased. Who should decide what sculpture should be put in a public place? What kind of sculpture should be put in certain places? Should sculpture placed in a playground be different from sculpture placed in a government building? A shopping mall? A school?

When thinking of art and the community, students might have a discussion centering on the question "Should the work of local artists who are not famous be displayed in a community, or should work done only by famous artists be shown?" This question is related to "What ought to be the purpose in exhibiting art in public places?"

Teachers and students will find issues in newspaper and magazine articles. For instance, a story with the headline "Artist Not Aborigine or a Man" reported that an artist who had been receiving much acclaim as one of the "most promising Aboriginal artists in Australia" was actually Elizabeth Durack, an 82-year-old woman of Irish decent. The artist, who used the name Eddie Burrup, worked in a dot-style technique typical of Aboriginal painting, and incorporated Aboriginal symbols and themes into "his" work. One of the artist's paintings was entered in a contest for a national Aboriginal art award; another painting was being considered for a prestigious award in landscape painting; and a third work was in a touring show. A question emerges from reading the article. Does it really matter if the paintings were done by someone who is not an Aborigine? The director of the institution responsible for granting the award said, "I don't give a hoot who painted it . . . We're not judging the artist. We're judging the work of art. So really what name is appended to it I don't think matters a great deal." On the other hand, a curator who exhibited three of Durack's paintings viewed the matter differently: "How dare anyone appropriate a culture like that? . . . Nothing justifies inventing an Aboriginal person . . . It's a massive fraud."[9]

Teachers and students can consider whether they can appropriately view an artwork on its own, ignoring the fact that it was created by someone posing as someone else. The extent to which contextual information is necessary for responding to artwork is an important philosophical issue for critics and historians. The director of the institution holds the view that this information is extraneous and not important. What do students think of this view?

The curator raises another issue when she implies that the artist has appropriated a culture. Is it possible to appropriate a culture? When we think about the ways in which Picasso and other artists working in the early part of the twentieth century incorporated certain stylistic characteristics of African art, we might wonder how the work by these artists is different from the "Aboriginal" paintings by Durack. To what extent has either appropriated a culture?

We might also wonder whether what Durack has done can be considered fraud. Are there not other historical examples of artists' using pseudonyms? The popular writer Anne Rice, for example, has writ-

ten under the names Anne Rampling and A. N. Roquelaure. There are many cases in which women artists have used male names, presumably so that their work would be seriously considered in a predominantly male art world. Are there certain circumstances that allow for this kind of "deception"?

At times, contemporary philosophical issues might be even closer to the interests of students. Recently, a school principal in Florida banned a student's drawing of a nude male from a class exhibition, but did not ban a drawing of a nude female. This event prompts general questions about censorship, appropriate content for school exhibitions, whether school exhibitions ought to be governed by standards different from other exhibitions, and whether there should be different standards for depictions of nude males and of nude females.

The media contain many such stories that give rise to philosophical inquiry. Teachers can scan local newspapers, artworld magazines and journals, lesson plans from the Internet, and teaching magazines in search of these. As students become more experienced in recognizing philosophical issues, they also can be on the alert for such issues and questions.

In planning for philosophical inquiry within the art curriculum, teachers must identify questions, issues, and topics that are relevant for student exploration. In addition to reviewing student questions raised in other contexts, teachers can consider the philosophical implications of unit and lesson themes, the issues embedded in other parts of the art curriculum, and issues associated with artworks that will be used within units or lessons. Teachers also might identify relevant philosophical questions, issues, and topics as they appear in current events within the local, national, or artworld communities.

The examples of questions and issues within this chapter demonstrate that teachers beginning to design activities for philosophical involvement need only reflect on components of the curriculum already in place. Such questions and issues await the careful attention of and recognition by teachers who, with practice, will probably identify more topics than they will ever be able to find the time to discuss with their students.

Notes

1 Comment recalled in obituaries reporting the death of Matisse, 5 November 1954.

2 Alexander Melamid et al., "Painting by Numbers: The Search for a People's Art," *The Nation*, 14 March 1994. Variations in percentage totals are found in the original.

3 Marttila and Kiley, "The Experts Speak," *The Nation*, 14 March 1994.

4 Andre Chastel quoted in Ginger Danto, "What Becomes a Legend Most," *ARTnews*, Summer 1989, 148–151.

5 "I Was Homeless—Now I'm Art," *Utne Reader*, January-February 1997, 34.

6 (AP) "'Living Paintings' work on artist's hang-ups," *The Morning Call*, 11 February, 1988, sec. A, p. 32.

7 Seventh grade student responses, Western Branch Middle School, Chesapeake, VA; Jennifer Bright Blazek, art teacher.

8 These seventh grade student responses were distributed by a participant in a workshop for art teachers held by the author. No identification of art teacher or school was provided.

9 (AP) "Artist Not Aboriginal or a Man," *Reading Eagle/Reading Times*, 8 March 1997, sec. A, p. 3.

Activities for Philosophical Inquiry

One of the more rewarding experiences a teacher can have is seeing students excitedly debate a philosophical issue of relevance to them, energized with new ideas and questions. Whether spontaneous or planned, philosophical dialogues can provide meaningful experiences for both students and teachers.

After selecting a range of questions to present to students, teachers must then decide how to incorporate them into well-designed activities for philosophical inquiry. Activities presented in this chapter might be built upon or adapted for use with different age groups and classroom settings. Many of the activities require that students participate in philosophical dialogue. Some imply that a dialogue be held with the entire class; others lend themselves better to small-group involvement. Following the guidelines for philosophical dialogue in Chapter 3, teachers and students who function as facilitators can move a discussion along to a productive end, regardless of its format.

Great Debates

In great debates, philosophical issues or questions are posed for students to consider. Since the purpose is to explore the issues at hand and even generate new questions, there are no winners or losers, as such; thus, these discussions need not be subjected to formal debate rules. A great debate may involve the whole class, wherein students are encouraged to state their own views regarding the issues at hand; or the class might be divided into teams who take a specific stance and argue accordingly. Great debates might also be held within several small groups, and again, members of the group might articulate their own positions or form teams arguing a particular point of view. Each small group might be asked to consider a different issue or question, creating a classroom in which several issues are debated at the same time. In such cases, time should be set aside for reporting to the entire class. Whether working in a large group or several small groups, students may or may not be given time before or during class to prepare their arguments.

A Great Debate: King Tut's Tomb

Issues for debate might be posed within the context of hypothetical scenarios or real-life cases. In this example, we see how a great debate can be part of a unit of study. Jeff Dietrich, an elementary art teacher in Oley, Pennsylvania, asked his students to voice their views about a situation that actually occurred.[1] Dietrich describes the course of study:

In a third-grade unit on Egypt, I talk about the fact that some unsavory ancient Egyptians were prone to robbing royal tombs to steal the valuables. We spend a class period going over the discovery of King Tut's tomb in 1922. The students learn about Howard Carter and his benefactor, Lord Carnarvon. We talk about the fact that most of Tut's belongings are on display in museums for people to see, and then I show them pictures of Carnarvon's castle and the secret cabinets where some treasures from Tut's tomb were recently found.[2]

Students were asked to consider the following: *In ancient Egypt, tomb robbers hunted for the burial sites of the Egyptian rulers, with the intent of robbing the graves of all their valuables. Many times, they were successful. Do you think Howard Carter and/or Lord Carnarvon, who discovered and emptied King Tut's tomb in 1922, could be considered robbers? Why or why not?*

The students completed worksheets to prepare for the discussion. This particular activity shows that when we begin to think about art and its role in society, we often must consider not only our beliefs about art, but also how these beliefs relate to our moral beliefs. As students considered this question, they were thinking philosophically in an area in which ethical and aesthetic issues overlap.

Role-playing

One reason for students to become involved in philosophical inquiry is to understand that people have different beliefs about art, and that these beliefs often inform the positions they take regarding certain issues and questions about art. When we ask students to role-play, we give them the opportunity to take alternative perspectives, aiding them in developing or refining their own beliefs and, perhaps, in developing empathy with those who have views different from their own.

Students might assume roles as they take part in great debates and in other formats designed for philosophical inquiry. The roles to be assumed can vary. They might reflect traditional theories of art. Depending on the issues to be debated, the roles

Student Responses
(grade three)

"No, because it was Howard Carter's job. Lots of people dig up things."
—Alex

"I do not think he wanted to rob King Tut because he probably wanted just to learn about King Tut and about what the Egyptians did way back then."
—Brent

"I think Lord Carnarvon was definitely a tomb robber because he had hidden compartments in his house with treasures in them. Robbing King Tut's tomb was wrong!"
—Nikki

"I don't think they should be considered robbers because they are discoverers. They find things for museums for people to learn about history."
—Megan

"Half of me thinks yes. Half thinks no. Why would he keep some of King Tut's things without being a grave robber? Was he dared by someone? Maybe or maybe not. Who knows? On the other hand, maybe he wanted to find out what King Tut's grave looks like."
—Amanda

"Yes, I do. He had no right to touch Egyptian artifacts. They belong to the Egyptian government. Recently, people found miniature treasures hidden behind a panel in Lord Carnarvon's castle."
—Jonathan

"No, I don't think he is a robber because he didn't steal it—he put it in a museum. On the other hand, I think Lord Carnarvon is a robber because he stole some treasure and hid it in his house and didn't tell anybody."
—Tarah

"No, Howard Carter is not a robber. The treasure should be in a museum so everyone can see it. People can learn a lot about it."
—Stacy

"I believe that Lord Carnarvon and Howard Carter were robbers. I believe that the treasures they found were put there to stay there. The treasures were not theirs, and they did not ask the people permission to take the treasures. They should have kept the treasures in the country they were found in and helped to open a museum there, so people could see the things without taking them out of the tomb."
—Jamie

"It was wrong to rob the graves, and . . . the valuables should be returned to the Egyptian people because the valuables belonged to the Egyptians in the first place."
—Brad

Beliefs about Art

Below are examples of what can be presented on "belief cards" given to students for role-playing in hypothetical situations.

- You believe that art should show ordinary things in new ways.

- You think that art has to be made out of traditional art materials (clay, paint, etc.) by an artist who uses her or his hands to create it.

- You think that all art should have a message or a story about how to be a better person.

- You believe that art is anything that you like.

- You believe that art should always show or express feelings.

- You believe that artworks have to be unique—different from other artworks.

- You believe that art should look like other things in the world. A painting of a clock, for instance, should look like a clock.

- You believe that art should be something that people like to look at; it must "please the eye."

- You believe that art should make people think.

- You believe that art should take a long time to make and be very well made.

taken might be those of community members—children, police, an office worker, parents, a school-board member. Roles might reflect actual positions taken in response to community issues and found, perhaps, in letters to the editor. Students might create their own characters with certain beliefs about art that may or may not coincide with their own personal beliefs. They might also take roles from characters in stories; for example, younger students might imagine how Charlotte, from *Charlotte's Web*, might react to the issue being discussed.

Role-playing in Hypothetical Situations

A Gift for the Museum

In this scenario, students assume the role of board member of a local museum. They must decide whether a particular gift should be accepted by the museum for display. The objects considered might be found objects, natural objects, commercially pro-

5.1 *A mixed age group of students participate in the role-playing activity,* A Gift for the Museum.
Photo: Jeffrey Dietrich.

duced packages, items from popular culture, ordinary household items, or objects that seem more like "real" artworks. Similar objects with different histories might also be used. Each student is given a card on which a different belief about art is explained. In assuming their role, students must consider how a person who holds the belief on the card would argue, given the specific object as a candidate for the museum collection. This may be a small-group activity, in which one member assumes one of the roles; or a large-group activity, in which pairs or small teams collectively assume the role.

"Forgetting" Roles

When students assume roles and enter into a discussion about the problem at hand, they may get so involved that they "forget" their roles and argue from their own perspective. Because the most important purpose of any of these activities is to provide students with opportunities to reflect on the issues and, ultimately, the beliefs and questions they have about them, the teacher need not insist that the students maintain their assigned roles. During great debates and any other philosophical discussion, students may bring forward questions and philosophical problems dealing with issues other than those directly connected to the initial hypothetical situation. Again, this is not necessarily a problem. Teachers can allow the discussions to wander; they might even take advantage of the change of direction.

Role-playing with Two Roles

Rather than individual students assuming a specific role, the class might be divided into two groups, with each group representing a different perspective. The teacher constructs a hypothetical scenario and assigns a position to each group. The group members construct arguments to support their assigned position.

Changing Direction: Considering the Role of Museums

In discussing the issues in the debate about the gift to the museum, students might say that acceptance of the gift depends on the type of museum or the primary purpose of the museum.

Some people believe that museums should preserve the very finest objects created by humans. Others believe that museums should display any object related to a particular period, topic, or idea, regardless of the quality of the work. Some people believe that the main purpose of a museum is educational and that all objects on exhibit should be accompanied by labels providing substantial information about them; others believe that objects should be accompanied by a minimum of information, allowing viewers simply to enjoy the object on its own.

There are differences of opinion regarding the way museums should look— some arguing for a simple, clean environment with bare white walls; and some arguing for settings like those in which objects would be found in the real world. People who enter this discussion might say that the look of a museum depends on what purpose the particular museum has.

These and other views about museums might be placed on role cards for students to use when considering the role of museums in society.

5.2 Anonymous, Sea captain, undated. Painted wood, 6.5" (16.5 cm). Courtesy Helen Ronan. Photo: Tom Fiorelli.

In this scenario, students are to select an object as an official symbol of the American spirit. They are told that the selection committee has narrowed the choice down to two objects. One is a carved and painted wooden figure of a New England sea captain. The other is a Pepsi Cola can. Each group of students is assigned an object to promote for adoption. As group members offer reasons for adopting their object, they are forced to consider it in ways different from how it has been seen in the past. Those arguing for the sea captain, for instance, might argue that it symbolizes American resourcefulness and hard work in the face of life-threatening forces. Arguments for the Pepsi Cola can might center on the ways in which the product has been marketed along with an upbeat, fun-loving, and diverse public. The discussion may become more complicated when it is pointed out that the sea captain figure was made in Taiwan or that the Pepsi can is, indeed, empty. Because in this scenario students are not allowed to change roles, they are compelled to move beyond more obvious arguments, resulting in some fine thinking on their part.

Role-playing in "Real Life" Debates

Tilted Arc

One of the most famous debates about a public artwork was about contemporary sculptor Richard Serra's large sculpture *Tilted Arc*, commissioned by the federal government to be placed in the plaza outside a New York City office building. The piece was 12' (3.6 m) high and 120' (36.5 m) long and was positioned so that people had to walk around it and could not see beyond it if seated on one of the benches at the edge of the plaza. Many office workers were accustomed to having their lunch on the plaza or enjoying the fresh air during their breaks. The placement of the sculpture was the

The *Tilted Arc* Hearing

(excerpts from the hearing)[3]

In favor of relocation:

"It used to be very pleasant to walk out of the building and see an open space . . . and see people sitting on the ledge of the fountain talking or having lunch or sunning themselves. Now, all we see is a very unattractive slab of discolored metal . . ."

"We are not here to discuss the merits of the sculpture, but only the place it was put. Its placement is, at best, hostile to its environment, and it negates the use of the open space. Mr. Serra's work of art . . . was designed to change, alter, and dislocate someone else's artistic creation. This is wrong."

"This gigantic strip of rust is . . . an arrogant, nose-thumbing gesture . . ."

"Rather than an arc, it is a wall with all the actual and symbolic connotations of lost freedom the law implies. Confinement, restriction, obstruction, and exclusion . . ."

"After being surrounded by four walls all day, the last thing I want to face is another wall."

"Neither its shape nor its color nor its materials are compatible with the other elements already existing there."

"I just want artists, if they want support from the community, to consider our feelings as well."

"There is a lesson to be learned from this . . . you don't go to Washington alone for approval of something placed in New York. You go to your own surroundings and get some input from the people. They are not all ignorant dunces to be ignored and presented with a fait accompli."

In favor of retention:

"History . . . teaches us that art, to be a valid expression of our culture, requires freedom for the artist to make his statement about the life and times in which the artist lives and works."

"The removal . . . would set a dangerous precedent and erode people's confidence in the government's (commitment) to commission permanent works of art."

"So, we are here apparently to judge something that only time can judge because this is the only true test."

"Richard Serra's *Tilted Arc* is a powerful work of great artistic merit . . . I have never heard of the removal of a public monument having been settled by popular vote . . . The decision should . . . involve the sentiments of a much wider circle than simply those who work in its immediate neighborhood."

"In time I predict that even the most concerned people working in this plaza will look on the sculpture with pride."

"Art is not democratic. It is not for the people."

"The [sculptural] planes move and shift at different rates of speed, slow and fast, and I enjoy the movement from convex to concave . . . I can imagine choreographing movements around and against this curve."

"There was a legitimate contest and the selection was made by accredited agencies . . ."

"There aren't any tribes . . . in the history of mankind that destroy their totems and . . . that is what you are purporting to do here . . ."

"One of our goals is to alter your perceptions, increase your awareness of the visual world. We are presenting gestures that point to the future. Don't send it back to the dark ages."

"The artist here was specifically and formally assured that his work would be permanently installed in an environment where he intentionally planned a harmonization with the environment."

source of much controversy and became the subject of public hearings. Eventually, after many hearings, the sculpture was removed. Citizens, some of them members of the artworld, presented their views in the hearings. Their statements revealed various beliefs about art and its role in society. The positions taken might be paraphrased and given to students to consider and role-play as they debate the issues associated with the *Tilted Arc* case. Students might also assume these positions as they consider other works of public art.

The Sistine Chapel

Another debate that received international attention had to do with the implications of restoring the ceiling of the Sistine Chapel. Many art historians were surprised to find that Michelangelo had used vivid colors in the ceiling's frescoes; the traditional view held that he was not a colorist, but a sculptor interested more in form than color. Carefully argued art-historical positions were put into question when the restoration revealed a brightly colored ceiling, raising further questions about the nature and veracity of art-historical information. As with the Sistine Chapel ceiling, the restoration of artworks suggests various issues. Should an artwork always be restored to its original condition? *The Last Judgment,* on the wall of the chapel, had seen changes since Michelangelo originally painted it. In 1564, Pope Pius IV ordered artist Daniele da Volterra to cover up the most "indecent" nudes. According to one view of restoration, the history of an artwork should be preserved, and since the covering of the nudes is a part of the artwork's history, they should remain covered. The other view is that the work should be restored to the way it was created by the original artist. A factor to consider is the belief held by some historians that Daniele da Volterra actually removed the nudes, and

did not simply paint over them. In this case, should someone be commissioned to repaint the Michelangelo nudes, or should the current figures be painted out and the areas left blank? Students might do their own research about restoration guidelines and the case of the Sistine Chapel, in particular, and then discuss the various positions in a great debate.

Extended Role-playing

As students gain a better understanding of various philosophical positions and the thinkers who have promoted them, they will be able to take part in another kind of role-playing activity. When they take part in philosophical discussions—and even when involved in other experiences in the art curriculum—students assume the role of individuals who have certain views about aesthetics issues. For instance, a student might assume the role of Tolstoy while considering particular works of art during art-criticism discussions. This activity might also have students take the perspective of someone representing a particular culture or period of history in which views about art can be identified and expressed through the role-playing activity.

A year-long activity might have students take the role of a particular thinker or representative from a specific culture in certain activities throughout the curriculum. Each student involved would need to do initial research and continue the investigation throughout the year in order to role-play appropriately as various issues or topics emerged. A student in this role might also create artwork according to principles or standards representative of that thinker or cultural group.

Drama

The various role-playing activities suggested above draw on students' interest in taking part in dramatic play. Drama might be emphasized even more, however. Students might dramatically interpret stories and essays they have written, taking the role of developed characters and addressing philosophical questions and issues. Students can also reenact events reported in the media, elaborating on and extending the various positions taken by individuals central to the event. Mock trials; museum tours led by docents with a particular point of view; archaeological expeditions; video interviews with particular artists, critics, historians, or philosophers; and other similar scenarios can be dramatized and presented by students.

As with any role-playing activity, students are required to think carefully about points of view and how to play them out in various scenarios. They thereby extend their understanding of how beliefs about art inform decisions and actions on the part of those who hold them.

In-Out-Maybe

In-out-maybe is an activity that lets students present their views on any number of topics. In one version, students are shown a variety of objects or are presented with photographs and/or descriptions of objects or events and asked "Is it art?" What is "in" are the things that students agree are, indeed, art. Things that the students do not consider to be art are "out." Interesting discussions typically occur as students state their views and sort through issues regarding problematic items.

Objects selected for this activity can be chosen randomly, but they may also be chosen to coincide with topics addressed within a unit of study or because they have certain connections with one another. A teacher may select several objects of the same general type—baskets, for instance. One basket might be handcrafted by a contemporary basket

5.3 *Third graders play* In-Out-Maybe.
Photo: Jeffrey Dietrich.

maker; another might be handcrafted but from an earlier time; another might be mass-produced by machinery; another might be mass-produced but handcrafted, with an established pattern; another might be a basketlike object—a plastic bowl made to look like a basket. As students become familiar with the context in which each was produced, they may decide to change their *in-out-maybe* position and discuss such issues as mass-production and originality.

In-Out-Maybe *Formats*

In-out-maybe may be played with two circles, one for those things considered "in," and one for those things considered "out." The circles overlap to create a space for those things that may or may not be art. A bulletin board with overlapping circles (like a Venn diagram) or with columns for each category might be created and even displayed in the classroom permanently. What falls within each category

will depend on the question addressed. For example, with the question "Do all artworks tell us about the culture in which they were produced?" the categories are changed to "yes," "no," and "maybe." Students might record their views on 3 x 5" cards (perhaps adding their own photographs or drawings) and place them in the appropriate place within the diagram. Any philosophical question can be adapted for use with this activity.

Through *in-out-maybe*, students learn that categories in and questions about art are complex. They also learn that responses in this activity will vary, depending on different assumptions about the nature of art.

A Journal for Thoughts about Art

Even though students are encouraged to enter group discussions, some will likely remain quiet. However, all students should have the opportunity to reflect on the issues brought up and on their own views, regardless of the extent to which they were noticeably involved in the discussion. In a journal devoted to thoughts about art, students can note statements made with which they agree and those with which they disagree. They can indicate questions that they still have about issues addressed. Journals can function as a place for private reflection but also might be shared in pair interviews or in small or large groups.

When they know in advance that they will be required to write in their journals, students will likely listen more carefully. In addition, a journal of this type provides a record of their own views and the changes in these views over time. Students might use a three-ring binder to hold worksheets designed for reflection on specific dialogues and questions, and those for the practice of various skills related to philosophical inquiry. Students

might expand their journals to include all reflections and notes about art, including criticism essays, art-historical notes, ideas, research, and resources for art-making—a kind of "idea book" that also serves to document student progress.

Worksheet: Thoughts about Art

What is art?

1 Today I considered the following ideas and questions:

2 The characteristics of art that I consider to be most important are:

3 My definition of art, thus far, is:

4 Questions I would like to think about:

Questions in the Air

Teachers may wish to add to the inquiry environment by "planting" philosophical questions. One teacher "plants" philosophical questions in various spots within his high-school ceramics studio. Above the clay bin, he posts a sign with the question "Can a lump of clay pulled from this bin be art?" Other signs around the room ask such questions as "Is there a

5.4 As students reflect upon their own values and beliefs about art, they consider influences from family, peers, ethnicity, and membership in social groups. High-school student, Daniel Boone High School, Birdsboro, Pennsylvania. Photo: Karen Shriner.

Discussion Point:
Exhibiting Bad Art

The Museum of Bad Art (MOBA) opened in 1996 in the basement of a home in the West Roxbury section of Boston. It has a permanent collection, regularly mounts exhibitions, and has openings (imitation cheese puffs and spiced wine are served). According to one of the curators, bad art is in the eye of the beholder. Seventy-five percent of works submitted to the museum are rejected because they show too much technical skill. Some items are rejected because they are not original (a yellow happy face, for example).

Guidelines for bad art include "unusual use of color, interesting and different perspective, and strange subject matter." The curators never pay more than $6.50 for a piece of art. About the artists, a curator says, "We hold them in high regard. So far we have identified about twelve of the artists included and not a single one has been offended. After all, MOBA is celebrating the right to fail."[7]

The museum has a board of directors, its own Web site and a book, *The Museum of Bad Art: Art Too Bad to Be Ignored* (Andrews and McMeel). It also has loaned some of its collection for exhibits.[8]

- Why would someone create such a museum?

- What would account for so much interest in "bad" art?

- Do you agree with what Oscar Wilde said about bad art? "Bad art is a great deal worse than no art at all."[9]

difference between crafts and art?" and "What do we mean by 'craftsmanship'?"[5]

Other teachers provide students with a question for the week. Still others move amongst groups of students working on various studio projects and raise philosophical questions for them to consider as they work. With these prompts as springboards for philosophical inquiry, students can hold their own conversations on the way to their next class, on the playground, during lunch or after school, or at home with family members. Another teacher routinely provides students with a take-home handout that tells a story or provides a scenario that raises philosophical issues. This teacher tells of encountering parents who have themselves become interested in the questions raised by these handouts, and report having family discussions that continue over a period of weeks.

Students too can be responsible for involving the school community in philosophical discussions. In one school, the students work with their teacher to create a "Thoughts about Art" bulletin board that is displayed in the cafeteria. Issues are presented and questions posed. Responses are collected and published in the school newspaper.[6]

Object Ranking

In this activity, students rank works of art or objects according to their importance. As they assign each object a rank, the students list reasons for their decision. In one version of this activity, the teacher or students determine in advance what they mean by "importance." Definitions might be drawn from different philosophical beliefs. For example, drawing from the Formalist theory of art, an object might be said to have importance to the extent that it has good overall design. Importance might mean that an object has the most potential for changing the way people think or behave, reflecting one version of the

Instrumentalist view. Importance might also be associated with originality or uniqueness, expressiveness, or the degree to which it reflects the real world. In each of these cases, even though students have agreed on what importance is, they will invariably rank the objects differently and should be encouraged to discuss the reasons for their decisions. The heart of this activity is the thinking that the students do and the discussion that follows their attempts to rank the objects, because it is here that they will need to reflect on their beliefs, listen to the views of others, and perhaps even change their mind.

Another version of this activity is to have students rank the objects from 1 (indicating the greatest importance) to 10 (or any other number that indicates how many objects are to be ranked), without having them first decide what they mean by importance. Ask the students to make the ranking decisions alone, according to what they think importance is, and then have them discuss their rankings.

Analyzing Philosophical Writings

Students will be increasingly able to identify philosophical assumptions as they take part in philosophical dialogues and other related activities. Both students and teachers can collect newspaper articles, essays, and statements by artists, philosophers, critics, and art historians. Students can then analyze these writings in an attempt to "uncover" assumptions. Students can put into their own words the writer's views about art or particular issues. They should be able to give the reasons stated for these views.

Conducting Interviews

Conducting interviews is one way students can learn that people hold different beliefs about art and various aesthetic issues. Students and their teacher can identify people to interview. The questions to be

Worksheet: Object Ranking

Assign each object a number from 1 to 10, with 1 being the highest, in terms of how valuable or significant you think the object is. Note your reasons in each case.

Object	Number	Reason
A		
B		
C		
D		
E		
F		
G		
H		
I		
J		

5.5 High-school art students pair off to discuss their philosophical beliefs. Photo: Karen Shriner.

asked will depend on the topic or issue under consideration. Interviews are not polls: the point of the interview is not to take a count of those who hold specific positions, but to conduct an in-depth examination of the beliefs that people have and their reasons for them. Students can share their findings with one another in class time set aside for this purpose. They might then categorize the kinds of responses encountered and interpret the data in general terms.

Token Response

A popular activity among art educators is playing the game *Token Response*, a teaching resource developed by Drs. Eldon Katter and Mary Erickson.[10] Students are given symbols that indicate responses to artworks—responses made before spending much time interpreting them. By placing these symbols near the artworks, students indicate which ones they love, which they dislike, which they believe to show the best use of materials and techniques, which they would like to have in their home, and so on. One of the ways to use this resource is to have students note how they have responded to the artworks and to make general statements about these responses. This preliminary activity prompts many questions about the difference between preference and judgment, about why people tend to respond to certain kinds of art the way that they do, and about criteria that ought to be applied in making judgments about artworks.

Stories and Other Writing

Some writing activities are especially conducive to interdisciplinary work in which teachers of other subjects are involved. With the language-arts or English teacher, in collaboration with the art teacher, students create stories in which philosophical issues are raised. Characters who hold different points of view

are developed. As the story unwinds, the issues are addressed in narrative form.

Students might also create personal narratives in which they reflect on their experiences with art, attempting to uncover their beliefs about art and the ways in which these beliefs have been formed. Over time, they consider people, events, and cultural factors that have influenced their thinking about art; and whether their beliefs have ever changed and the causes for these changes. Teachers might provide questions for students to consider as they create these narratives.

Poetry forms such as haiku or cinquain offer opportunities for students to simply and succinctly express their beliefs and/or questions about philosophical issues. Students might include their writings with exhibitions of their visual works, or they can collect the writings in a book they have made for this purpose.

Students can make their writing even more public. Particularly if the local community is involved in a debate about aesthetic issues, students can be encouraged to state their views in letters to the editor of the local newspaper.

The art teacher and social studies or history teacher might have students routinely attend to the beliefs about art prevalent in different societies throughout the world and over time. Students can be asked to consider the uses to which artworks have been put in these different cultures. These can be compared to ideas and uses prevalent in the students' families or communities.

Student Artworks

Students' beliefs about art might be the focus of their creative work in various media. They can create drawings, paintings, sculpture, videos, computer displays, and magazines that address philosophical

questions, issues, and topics. Students can explore the work of artists who also have been concerned with some of these issues, noting how these artists have used media and techniques to convey their beliefs or prompt philosophical questions. Students can be asked to think about and express their views through artwork as philosophical issues arise in areas of their life beyond the art class. For instance, students might create artworks that deal with their views about censorship, copying, or public art. Ideally, philosophical inquiry is always integrated within the art program so that student involvement in studio work, in art-historical inquiry, and in art criticism reflects an ongoing consideration of their philosophical beliefs.

The philosophical questions, issues, and topics presented in this chapter—and those that emerge when students and teachers become accustomed to recognizing them in the context of their engagement with art—can be presented through a range of formats and activities. This chapter has provided some ideas for capturing the interest and imagination of students in the process of developing and refining their beliefs about art. Teachers are encouraged to draw upon knowledge of their students to design activities that are consistent with their teaching style and program goals. All activities in this chapter are designed to be open-ended; this is consistent with the view that ideas about art are ever unfolding. Teaching aesthetics is thus a generative process through which students attach what they believe to ideas that are new to them, emerging with questions that they never dreamed they would have.

Notes

1 Third grade students at Oley Valley Elementary School, Oley, PA; Jeffrey Dietrich, art teacher.

2 Professional correspondence. Jeffrey Dietrich, art teacher, Oley Valley Elementary School, Oley, PA, 1994.

3 These comments have been selectively excerpted from those included in the decision reached by a panel convened by William J. Diamond, the regional administrator of the General Services Administration, to hear testimony regarding the possible relocation of *Tilted Arc*. The hearing was held March 6-8, 1985. The decision is reproduced in Sherill Jordan, Lisa Parr, Robert Porter, and Gwen Storey, (eds.), *Public Art, Public Controversy: the Tilted Arc on Trial*. (New York: ACA Books, 1987), 167-177.

4 Nanci Hellmich, "A clean face for *Mona Lisa*?" *USA Today*, 15 August 1994, sec. D, p. 1.

5 Williamsport High School, Williamsport, PA, Robert Schultz, art teacher.

6 This practice was reported by a participant in the 1996 "Drawing Art Together" summer institute, sponsored by the Wisconsin-Illinois Network and the Getty Education Institute for the Arts.

7 Scott Wilson, quoted in Cathy Hainer, "Not-So-Fine Art," *USA Today*, 17 March 1997, sec. D, p. 4.

8 Cathy Hainer, "Not-So-Fine Art," *USA Today*, 17 March 1997, sec. D, p. 4.

9 *The Columbia Dictionary of Quotations* (New York: Columbia University Press, 1993).

10 *Token Response: Art Criticism and Aesthetics Game*, designed by Mary Erickson and Eldon Katter (Tucson: CRIZMAC, 1991).

Chapter

6

Activities for Introducing and Practicing Skills

In addressing philosophical questions and taking part in the kinds of activities presented in Chapter 5, students practice critical and creative thinking. Through critical thinking, students evaluate ideas. They use their capacity to reason as they reflect on ideas and make decisions about what to believe or do. Creative thinking is generative. Students use their abilities to think creatively when they generate questions and construct new ideas. Critical and creative thinking complement each other within the activity of philosophical inquiry.

Thinking skills, like any other skills, are learned through practice. When students participate in philosophical dialogues and other activities involving philosophical inquiry, they have the opportunity to practice their thinking skills, but their learning will be enhanced if they are aware of the particular skills they are using. Students can be introduced to the skills of philosophical inquiry or provided opportunities to refine them by participating in activities designed especially for these purposes. Once they are aware of particular thinking skills, they can actively work toward their refinement while taking part in philosophical inquiry.

In this chapter, some of the most-often-used skills are explained, and suggestions for introducing and practicing them are presented. In most cases, these short exercises can be adapted as part of a planned lesson.

The first section introduces skills needed to distinguish philosophical inquiry from other kinds of inquiry. The practice exercises stress the importance of knowing how to identify and construct philosophical statements and questions while participating in art-related activities or during the course of philosophical dialogues.

Section two presents skills needed to clarify the problem or issue to be considered. The skills practiced in this section aim to help students avoid the frustration that occurs when parties in a discussion direct their comments to several different questions or problems. This tends to happen when participants are not clear about the central questions, assumptions, or factors involved with an issue at hand.

The skills presented in the third section are used to actively participate in philosophical dialogues. Practice exercises encourage students to listen carefully, ask relevant questions, and provide examples to clarify or support their points of view.

The fourth section centers on the need to provide reasons when offering philosophical positions. The exercises in this section provide opportunities for students to practice reason-giving and to learn how to identify good reasons when they are offered by others.

Finally, the chapter addresses the need for students to be careful with the use of language whenever they are involved in philosophical dialogues. Practice exercises are designed to help students learn how to carefully select words, agree upon the use of key terms, make distinctions about word meanings, and evaluate definitions.

Getting Clear about Philosophical Inquiry

Making General Statements about Art

In most artrooms, students have opportunities to talk and exchange ideas about many topics. They voice their preferences and ideas about artworks shown to them as well as their concerns about artworks they create. Student discussions in the artroom often center on events in the school and community, amid much talk about family and friends. When we participate in any kind of discussion, we adhere to informal conventions that guide the way we pose questions and offer responses. These conventions are socially learned and are rarely scrutinized with the goal of making them explicit. As we examine philosophical discussions with the intention of learning how to do better what we do naturally, we note that they are prompted by statements and questions of a particular type.

As we have seen throughout the book, philosophical inquiry in aesthetics centers on overarching questions about the nature and significance of art and its connections to those who encounter and respond to it. To engage in such inquiry, students need to

understand that the focus of discussion is not on specific works of art or specific events or experiences; rather, the focus is on general ideas about art or about experiences in making, viewing, responding to, and understanding art. In order to maximize their potential for gaining the fullest rewards of philosophical inquiry, students need to learn how to identify and make philosophical, or general, statements. To do this, students need to practice distinguishing such statements from the many other kinds regularly put forward in the artroom and elsewhere. Teachers can help students identify and make general statements.

Practice

Have students work in small groups to make summarizing statements that could be said about the nature and significance of all art, some art, or no art. Instruct them to focus on what all, some, or no art *is* or the ways in which all, some, or no art is significant or valuable. Depending on the focus of the lesson, replace art with sculpture, painting, photography, artists, or artworks. List the statements created by each group and invite discussion. Provide students with a worksheet with some statements that are and some that are not philosophical statements. Ask students to identify the philosophical statements. These activities can be included as part of a lesson in which students have also been involved in art criticism, art-historical inquiry, or studio production.

Identifying Statements for Discussion

In the context of philosophical discussions, some statements can or should be discussed. Others can be addressed through observation or by checking resources. For instance, the statement "Works of art always inform viewers about the artist" can be addressed in a philosophical discussion in which dif-

ferent points of view are presented and assessed. On the other hand, the statement "Photography was invented in the nineteenth century" can be verified by checking historical resources; it is not the kind of statement that lends itself to different philosophical points of view. Time ought not be spent arguing about when photography was invented. Students should be aware of the difference between statements to be discussed and statements to be checked.

Practice

Provide a reproduction of an artwork for the students to consider. Ask them to examine a list of statements and distinguish between those that should be discussed and those that can simply be checked.

Example

		Check	Discuss
1	This artwork was made in 1902.	_____	_____
2	This artwork is the best work of art made by this artist.		
3	This artwork has many yellow lines in it.	_____	_____
4	This artwork was made with paint.	_____	_____
5	This is not a very good artwork.	_____	_____
6	The artist was a woman.		
7	This artwork shows a good use of line.	_____	_____

Identifying and Raising Philosophical Questions

As with identifying statements for philosophical discussion, students need to know how to identify and raise philosophical questions that lend themselves to discussion. The most useful distinction is the general-versus-particular distinction. In aesthetics, philosophical questions are general questions about art, beauty, and our experiences with art and beauty. The question "In what ways are (all) artworks special?" is thus distinguished from the question "In what ways is this (particular) artwork special?"

Practice (Identifying Questions)

Provide students with a list of questions. They identify those that are philosophical questions.

Example

_____ Can an artwork express feelings that were not felt by the artist while making it?

_____ Do artworks "imitate" reality?

_____ Does this artwork by van Gogh tell us how to think about nature?

_____ Can a computer make art?

_____ What value or significance does this artwork by Jaune Quick-to-See Smith have?

_____ How many people are depicted in this artwork?

_____ Can something be art and not be beautiful?

Practice (Raising Questions)

Have students work in pairs or small groups to list philosophical questions related to an object, a newspaper article about an event or situation, a quotation, or an artwork. You might design a worksheet for student responses to these prompts:

Consideration of _____ (the object, article, quotation, artwork, and so on)

1 Issues:

2 Philosophical questions to consider:

 a.

 b.

 c.

 d.

Have students discuss their responses with the class. Note any questions that are (and are not) philosophical.

Clarifying What's at Issue

Asking Prior Questions

Some questions cannot be addressed reasonably until prior questions are asked. For example, if we ask "Is three-dimensional photography a kind of sculpture?," we would want to know whether there is such a thing as a three-dimensional photograph. Similarly, if someone states that all painters title their paintings after they have completed them; not before, we would want to ask, "*Do* all painters title their paintings?" To move to serious consideration of a question or statement, students should know how to "unpack" it by asking prior questions.

Practice

Students can practice raising questions (see "Questions to Ask") by considering a series of statements and questions that require "unpacking." They can work in pairs or small groups as they identify what must be clarified before the statements or questions can be seriously addressed. As an example, consider the statement "That can't be fine art because it didn't take a long time to make." We would first want to know how the speaker is using the term "fine": to describe good art or to designate

Questions to Ask

Students should develop the habit of considering the following questions whenever they are presented with a question or statement.

For a question:

1 What does the speaker or writer seem to want to know?

2 Am I clear about how all the words in the question are used?

3 With what must I agree in order to respond to the question?

4 What is my response to the question raised?

For a statement:

1 What does the speaker or writer seem to want me to believe?

2 Am I clear about how all the words in the statement are used?

3 With what must I agree in order to accept the statement?

4 If the speaker or writer is providing me with an argument (a conclusion with reasons for accepting it), are the reasons good?

5 Do I agree or disagree with the statement?

6.1 *Students can practice their skills in small groups. Here, high school art students practice raising philosophical questions. Daniel Boone High School, Birdsboro, Pennsylvania. Photo: Karen Shriner, 1997.*

a certain kind of art, as when we use the term to distinguish between "fine art" and "craft." Then, before deciding to agree or disagree with the speaker, we would have to recognize that agreement would mean accepting the assumption that fine art is art that takes a long time to make. This assumption is also the support for the statement that something is not fine art; thus, we would have to decide whether the reason is a good one.

Practice

Provide students with a statement. Have them identify from a list of questions those that should be answered before deciding to agree or disagree with the speaker or writer.

Example

Statement: If an artwork is ugly, then the artist was angry when she or he made it. But if an artwork is pretty, then the artist was happy when she or he made it.

1 Are you saying that all artwork that is ugly has been made by angry artists?
2 What do you mean by ugly?
3 Have you ever made ugly art?
4 How many times have you seen pretty art?
5 According to your view, can a happy person make ugly art?
6 What do you mean by pretty?

After students identify questions to address, hold a discussion about the concerns that are relevant and not relevant in order to agree or disagree with the speaker or writer. For example, concerns about the speaker's personal life (whether the speaker has made ugly art or seen pretty pictures) are not relevant in this case.

Identifying Assumptions

Related to the skill of asking prior questions is that of finding, or identifying, assumptions. This is an important skill to develop for rational discourse.

Practice

Have students consider statements and choose from a list of possible assumptions the one that seems appropriate.

Example

Statement: The fruit in that picture looks very realistic. The artwork must be a photograph.

Which of the following is assumed in the statement above?

1 Paintings are always realistic.
2 Photography is the only means by which something can be shown realistically.
3 Pictures are always photographs.

Considering Factors

Philosophical questions and issues are sometimes complex, with many things to consider while addressing them. Students should examine a situation for its related factors, and then consider those as they address the problem.

Practice Considering Factors

Ask students to take a position regarding a philosophically interesting situation. Have them identify factors to consider before they take a stand.

Example

A painting titled *Cats Play on the Roof* has become famous over the years. People have studied it, and reproductions have been made of it and put into art books. An art historian has found a diary written by the artist. In the diary, the artist says that he made a

Discussion Point:
Do Titles Really Matter?

"If I could think of clever titles, I'd use them, but mine are pretty mundane. *Sunrise* [and] *Sunset*, for example, aren't very interesting, but I know what we're talking about. It's much easier than trying to recall something titled *Landscape No. 8* or *Landscape No. 9* . . . It's for archival purposes. The process isn't intellectual, but it's required, I feel, and I usually put on the titles after the work is done."

—Roy Lichtenstein[2]

"I like titles. It doesn't matter a whit to me if people read them or not. But it rounds off the work. Their function is not to tell what's going on. Their function is to be evocative. To be read or not read."[3]

—Stanley Boxer

• Are titles important? To whom?

• If a work has a title, should it be displayed with the work? Why or why not?

painting and called it *Cats See Death on the Door-step*. He discovered that the person who bought the painting from him didn't like the title and changed it to *Cats Play on the Roof*. The artist writes in his diary that when he sold the painting, he had no money and didn't complain, fearing that he would lose the sale.

1 Should the title of the painting be changed back to the original one?
2 Name two factors to consider.

Engagement in Dialogues

Listening Carefully

To benefit from the ideas and insights of others as they develop their own set of beliefs about art, students need to know how to listen carefully to what others say. Good listening is a skill and, as such, can be developed through practice. The following activity can be used with students of any age group.

Practice

Form groups of three students, and give each group a reproduction of an artwork. Each student makes one or two statements about the work. The two "listeners" summarize what the speaker has said, and the speaker indicates which summary better captures the intended meaning. If there is a difference between what was heard and what was intended, poor listening might be the problem. On the other hand, the problem might rest with the speaker who isn't listening very well to her or his own statement.

Being an Active Discussant

We cannot assume that all students know how to be involved in a dialogue. To help prepare students for active and productive participation in philosophical discussions, teachers can provide examples of kinds of questions they might ask.

Practice

Provide students with question cards. During a philosophical dialogue, students refer to the cards and use the questions when appropriate. (Each student might be given a complete set of questions, or only one question.) Students are responsible for asking the questions at times they believe appropriate. Because they must wait for appropriate times to use their questions, students also practice the skill of good listening.

Urge students who are just beginning to learn how to participate in philosophical dialogues to pay particular attention to times during the discussion when they might ask for a reason, an example, or a clarification about what has been said. These students can use cards with simple questions such as "Will you give a reason?," "Can you think of an example?," and "Can you explain what you mean?"

More experienced students can learn how to use the following questions:[4]

Examples

- Why?
- What do you mean by_____? Can you give an example? Can you think of something that would not be an example?
- How does what you have said apply to this particular case? How do you know?
- What is your main point?
- Would you say more about that point?
- Do you have evidence to support your statement?
- How does what you have said make a difference?
- Are you saying that _____ ?
- How are you using the word _____ ?

Providing Examples

Thinking of examples to better explain a particular point is not always easy, but good examples always

aid communication. The facilitator of a philosophical dialogue can ask students to provide examples in the context of the discussion, but students also can practice the skill of giving examples.

Practice

Ask students to agree or disagree with statements and provide examples to support their position.

Example

Artworks can convey feelings.

☐ agree ☐ disagree

Supporting Example:

Knowing where, when, and under what conditions an artwork was made is important for understanding its meaning.

☐ agree ☐ disagree

Supporting Example:

Artists should be required to put titles on their artworks.

☐ agree ☐ disagree

Supporting Example:

Offering and Evaluating Reasons

Offering Reasons in Support of Statements

Students need to know how to offer reasons in support of their general statements. During the course of a dialogue, the facilitator (and eventually the other students) can reinforce this skill by routinely asking students to support their statements.

6.2 Fifth- and sixth-graders discuss their reasons for ranking a collection of pitchers. Two representatives from another group in the class will visit this group and ask them to explain and defend their decisions. Photos: Jeffrey Dietrich.

Student Writing

While teaching a unit on public art, an art teacher showed his fifth-grade students an article about a sculpture that had been in place for twenty-five years.[5] A group of people had recently deemed the sculpture an inappropriate statement about the historical figure it represented. The sculpture was removed. Because the class was involved in designing and constructing a large mural for their school, the issue was important to them. The teacher gave his students a work-sheet that contained the following:

WHAT IF . . . we finish the clay mural, put it up, and discover that a group of concerned citizens doesn't like it? These citizens go as far as petitioning the school board to make us remove our artistic contribution to the school and community.

1 How would you intelligently argue to keep the mural?

2 What important points could you make to the people who want the mural removed in order to change their minds?

6.3 Students stand proudly in front of the mural they created. Photo: Jeffrey Dietrich.

Student Responses

"Art is a form of speech. They would be taking away your constitutional right to express yourself in any form."
—Julia

"We want everyone in the future to see our mural. We want our children, grandchildren, great grandchildren to see what we did in the fifth grade."
—Lauren

"I would say that everyone has their own opinion about art. Apparently, these people have a different opinion. That's all right, but we put a lot of effort into making the mural. Maybe our brothers, sisters, and even our own kids will like it and be influenced by it. That's what I hope."
—Robert

"The art supplies cost money—like the glaze, the clay, and the paper for the drafting. If you throw this away, it would be like throwing money away."
—Joanna

". . . I would also point out that this mural might be famous some day and people will spend money to see it. It would make Oley [the town] famous and proud to know that some-thing wonderful was created here. This mural could start more opportunities for Oley. Jobs could be started and more businesses could get bigger. Soon Oley could be as big as Reading [the nearest city]."
—Justin

Practice

Provide students with a list of general statements. Ask them to choose two statements with which they most agree and to provide reasons for their selections. Divide the class into small groups in which group members tell one another about their choices and reasons. Ask each group to rank the general statements by level of agreement within the group. A "starter list" of general statements follows:

- All artworks are about something.
- Artworks always present what is true.
- Artworks are special because they make viewers feel good.
- It is possible both to like an artwork and to decide that it is not a good artwork.
- Artists should make artwork that people can immediately understand.

Recognizing Good Reasons

Students will learn that some reasons used to support statements about art make more sense than others. They can practice identifying sensible reasons.

Practice

Provide simple arguments, and ask students to consider whether the reasons in support of the arguments are good, fair, or poor. Give students worksheets with statements about art and a series of reasons in support of the statements. Students indicate which reasons they believe to be the best and are to be prepared to defend their positions.

Example

Citizens in a community are debating whether the city should again give money to artists to erect sculpture in the park this summer. Last year, artists submitted slides of their work and drawings and plans for the sculptures they intended to make. A group of citizens—including some art critics, artists, and art teachers—decided which artists would receive money to help pay for materials. Ten sculptures were put in the park, where they remained for one month. Following are summaries of some letters to the editor of the local paper. Tell whether you think the comments include good, fair, or poor reasons. Be prepared to explain your opinion to a small group of classmates.

A Some art is really good today, even though the artists aren't well known by most people. The art people who selected the sculpture know what art is the best, so we should put the sculpture in the park and learn about what the experts say is good, even though we don't like it much.
☐ good ☐ fair ☐ poor

B There are two kinds of art—art for galleries and museums and art for public places. The art for public places ought to be art that everybody likes. In Boston, a sculpture of Mrs. Mallard and her ducklings (from the popular children's book *Make Way for Ducklings*) was put near the Public Garden lagoon where, in the story, Mrs. Mallard and her ducklings go swimming. All art in public places ought to be like this—art that everybody likes. No artist should be given money unless the sculpture will probably be liked by everybody.
☐ good ☐ fair ☐ poor

C Since they are putting the sculpture in the park, it should blend in with the natural surroundings. Only give money to the artists who will make sculpture to blend in with nature.
☐ good ☐ fair ☐ poor

D Art in the park should not blend with the sur-
roundings. It should stand out so that everybody
can see that it is art in the park. This way, they
will see it and try to understand it. Maybe they
will even learn to like it.

☐ good ☐ fair ☐ poor

Attending to the Use of Words

Selecting Words Carefully

To communicate effectively, students need to care-
fully select the words they will use. They will discover
that in some contexts, words are vague, resulting in
unclear or imprecise meanings. They will also note
that some words are ambiguous and that others can
be used to evaluate something, prescribe a course of
action, and describe, thereby causing confusion as to
meaning. Students should strive for as much preci-
sion as possible.

Practice

Provide students with a worksheet that includes a
reproduction of an artwork and a series of state-
ments about the work. The students select the state-
ments that are the easiest to understand, because of
precise word choice. Students discuss their choices
with the entire class or in small groups.

Example

- The sculpture is a fine artwork.
- The sculpture is a good artwork.
- The colors are dark.
- The colors are dark shades of brown and black.
- It is rough to the hand.
- It has a rough texture.
- Everyone should like it.
- It is the kind of sculpture that a lot of people
will like.
- Everyone is required to like it.

Agreement about the Use of Terms

We may often disagree or agree with what someone has said, but then discover that the speaker used certain terms in ways different from how we use them. Understanding how key terms in a discussion are used is important for all participants. Students can ask speakers to define their terms so that all may respond appropriately. They can also work as a group to define key terms used in a discussion.

Practice Defining Terms

Post a list of terms—and their agreed-on definitions—used by students in their discussions about art. While stating their position during philosophical-inquiry activities, students select words from the list and thereby understand the importance of agreement about the use of terms.

Practice

The use of examples can help when defining terms. Have students work in pairs or in small groups to provide examples for questions such as the following:

1 Can a person interpret an artwork without understanding it?
2 Can a person understand an artwork without interpreting it?
3 Can a person interpret an artwork without describing it?
4 Can a person describe an artwork without interpreting it?

These are actually conceptual questions about distinguishing among interpretation, understanding, and description. In addition to learning how to provide examples, the students learn how to make conceptual distinctions.

Making Distinctions

To take a productive part in discussions, students must use language carefully, striving to be clear about the differences between terms closely related in meaning. To distinguish between the meanings is to make a distinction, and distinctions contribute to precise language. Students can practice making distinctions that will be helpful in philosophical discussions about art.

Practice

Have students explain one way that certain things are like art or specific art forms, and one way they are not like art or specific art forms.

Example

1 One way a Barbie doll is like art is:
 One way a Barbie doll is not like art is:
2 One way a flower is like sculpture is:
 One way a flower is not like sculpture is:

Continue the activity with objects such as a rock, a new car, an old car, a cereal box, and a wrapped birthday present.

Testing Definitions

One way to assess a definition is to determine whether it accounts for too much, in which case the definition is too broad; or accounts for too little, in which case the definition is too narrow. To test definitions, students can use counterexamples—examples that fall within the definition and are clearly not to be covered by it, or examples that fall outside the definition and should be captured by it. For example, the statement "A turtle is an animal that has shelter" is too broad if any other animals that have shelters are mentioned. "A painting is a work of art made with a brush" is also too broad if things made by using a brush that clearly are not paintings

Discussion Point: The Institutional Theory of Art

In an article about the 1993 Whitney Biennial, Arthur Danto claims that the institutional theory of art has been tested. He points especially to the installation of the complete videotape of members of the Los Angeles police force beating Rodney King, which was included as an artwork in the exhibition mounted by the Whitney Museum of American Art. The focus of this particular biennial was on artworks that deal with social issues.

The institutional theory is explained by Danto as the claim that "something is a work of art when decreed to be such by a loose constellation of individuals who are defined by their institutional identities to be within something called 'the artworld': curators, art writers, collectors, dealers and, of course, artists themselves who, for whatever reasons, put forward certain objects as candidates for assessment as works of art."[6]

Danto says that the King tape demonstrates how powerful images can be because of the impact the video has had on our society, and that the tape demonstrates "the limits of art" because "no work of art in recent (or perhaps any) time has had a fraction of the effect upon society that the King tape has had upon ours . . ." Danto maintains that the effect of the video images was in part "because they were not art, because they were the flat and uninflected effect of reality mechanically registered on videotape." The King tape was made by an ordinary person who happened to be there with a camcorder. The world, in watching the tape, believed implicitly that what they saw was the truth. Danto says that if people thought that the tape had anything to do with art, its effect on us "would be diminished."

Danto thinks that the tape might have been used in a work of art, and provides the example of Spike Lee's incorporating parts of the tape in the film *Malcolm X*. Danto writes, "Art as art really has certain limitations, and these are made palpable when we reflect on what the King tape would lose to truth if it were art instead of document."[7]

- Why is the King tape so powerful?

- Under what conditions might the King tape be considered an artwork?

- How is art different from "document?"

- What would it mean to test the institutional definition of art?

- How has the inclusion of the Rodney King tape in the Whitney Biennial tested the institutional definition of art?

6.4 Students can challenge each other to be clear in their use of words. Here, high-school art students test their definitions of art as they consider the artworks by Beverly Buchanan. Photo: Karen Shriner.

are mentioned. This same definition can also be too narrow if clear examples of paintings that are not made with a brush are provided. "A sculpture is an art object made out of marble" is too narrow if the counterexample of something we would agree is sculpture but not made of marble is given. Also, this definition can be too broad if an example of something made of marble but not typically thought of as sculpture is shown.

Practice
Have students practice showing that a definition is too broad or too narrow by providing counterexamples to definitions.

Example
Definition: A photograph is a picture that shows things as they appear in the world.
Counterexample: _____
 The definition is:
 ☐ too broad ☐ too narrow
 ☐ too broad and too narrow

Definition: An artist is someone who paints portraits.
Counterexample: _____
 The definition is:
 ☐ too broad ☐ too narrow
 ☐ too broad and too narrow

Many of the skills activities described in this chapter prompt philosophical discussions among students. A teacher can use the examples to create similar exercises that deal directly with topics in specific units of study. In this way, the exercises are not something separate from the day-to-day activities within the artroom; instead, they become an integral part of the study of art.

As students experience the pleasure of taking part in aesthetics discussions, they will increasingly see the need to refine their critical-thinking skills. Without the use of these skills, discussions can be confused and muddled. When students know how to clarify the issues associated with philosophical questions, when they know how to use words carefully, and when they know how to offer and assess reasons offered within dialogues, they learn to trust in the process and feel rewarded for their efforts. As they reflect on their own beliefs and how they have altered them as a result of careful thinking with their peers, they look forward to opportunities for more thought-provoking dialogues.

Notes
1 High school student journal entry, Wichita East High School, Wichita, KS; Brenda Jones, art teacher.

2 Roy Lichtenstein, quoted in Paul Gardner, "Do Titles Really Matter?" *ARTnews*, February, 1992, 93.

3 Stanley Boxer, quoted in Paul Gardner, "Do Titles Really Matter?" *ARTnews*, February, 1992, 93.

4 Robert H. Ennis, "Goals for a Critical Thinking Curriculum," in Arthur L. Costa (ed.), *Developing Minds: A Resource Book for Teaching Thinking*. (Alexandria, VA: Association for Supervision and Curriculum Development, 1985), 54–60. Robert Ennis lists questions such as these as "questions of clarification and challenge."

5 Fifth grade students at the Oley Valley Elementary School, Oley, PA; Jeffrey Dietrich, art teacher.

6 Arthur Danto, "The 1993 Whitney Biennial," *The Nation*, 19 April 1993, 534.

7 Ibid. pp. 534–536.

Philosophical Inquiry and the Art Curriculum

Whether through their responses to artworks made by others or through their own studio investigations, students develop beliefs about art and about ways in which they experience art. These beliefs are noted and nudged and, invariably, questions are raised when students explore ways to express their own ideas and wonder about meanings imparted through the artistic expression of others. To plan a curriculum in art without attending to the need and tendency to be reflective about experience is to ignore a central aspect of human involvement with art. In providing the opportunity to help students refine their beliefs and questions about their experiences in art, we are assisting them in developing understanding and skills that will be a part of their lifelong participation as art viewers and makers.

This chapter explores the curricular context in which philosophical inquiry is addressed. Preceding chapters have examined the activity of philosophical inquiry—how it results in various positions regarding art and experiences with art, how it might be conducted with students of art, and how students might be taught skills that will help them think productively about philosophical issues. Ultimately, philosophical inquiry must be addressed within the art curriculum. This is to say that it does not stand alone as a separate or the sole content in the study of art, but is integrated in relevant ways with other important content. Traditional art curricula include units, lessons, and activities through which students explore ideas, materials, and techniques for their own artistic expression; learn about ways in which art has been produced and responded to over time and throughout the world; and learn how to interpret meanings in and make judgments about artworks they encounter. When philosophical inquiry is included as an integral part of the art curriculum, students are given opportunities to reflect on their learning in these other areas and to see their own developing ideas as part of their more general understanding of art and its role in the human experience.

In thinking about the art program and the way in which philosophical inquiry can be addressed within it, we consider, in general, what students should know and be able to do as a result of their philosophical involvement; that is, we identify general learning outcomes. These general outcomes in aesthetics need to be considered in light of even more general goals for schooling. To have an art program through which students increasingly develop understanding and skills associated with philosophical inquiry, general outcomes in aesthetics need to be "unpacked" to reveal specific outcomes to be

addressed sequentially throughout the art program. With these learning outcomes identified, instructional and assessment strategies can be designed with specific students, learning contexts, and teaching and learning styles in mind.

Alignment, Assessment, and Outcomes

Most school districts have identified a set of core outcomes, goals, or objectives that in many cases are not discipline-specific. Core goal statements indicate what schools should provide for all students as they exit the system and include such things as the development of attitudes and skills associated with being a good citizen and a lifelong learner; the development of self-esteem; and the development of skills for critical thinking, problem solving, gathering and assessing information, and making sound ethical judgments. School-district core outcomes are often aligned with or are even the same as such outcomes at the regional or state level. Learning in specific subject areas is assumed to contribute to the development of understanding and skill in broader areas. Outcomes identified for K–12 programs in math, science, social studies, the arts and humanities, and so on are to contribute to the development of what is included in the core. Program outcomes are further delineated for courses of study at specific grade levels.

Vertical Alignment

Vertical alignment refers to the configuration of outcomes on a continuum from those stated in the most general terms to those stated in the most specific terms—from national, state, regional, or district outcomes to the specific teaching/learning strategies within a particular lesson. Educators should be able to demonstrate how a particular outcome stated at the level of a unit of instruction is a part of or leads

to learning at the more general levels (the program, district, state, and national levels) and encompasses learning at the more specific levels (the lessons within the unit and the activities within the lesson).

Core Goals/Outcomes

Program Outcomes

Course/Level Outcome

Unit Outcome

Lesson Outcome

What follows shows how vertical alignment for an outcome in aesthetics at the lesson level is related to typical outcomes at the unit, course, program, and core levels.

Core Goals/Outcomes[2]
All students will possess and use the knowledge and processes necessary for the development of: responsible citizenship, the habits of lifelong learning, self-esteem and confidence, critical-thinking skills, problem-solving ability, the ability to gather and assess information, and the ability to make sound ethical judgments.

Program Outcomes (arts and humanities)
All students will interpret meanings in and make judgments about works in the arts and will understand the aesthetic basis for their views.

Course/Level Outcome (visual art at the fifth-grade level)
All students will interpret meanings in and make judgments about visual artworks on the basis of several different philosophical perspectives.

Unit Outcome (one of several in visual art at the fifth-grade level)
Students will learn the basic tenets of the philosophical perspective of Expressionism and apply these to visual artworks they encounter.

Lesson Outcome (one of several in a unit at the fifth-grade level)
The students will identify assumptions in various statements about art as they relate to the philosophical perspective of Expressionism.

Within this example of vertical alignment of outcomes in aesthetics, the outcomes of the lesson can be seen as contributing to the student's ability to take part in the outcomes planned for the unit. The unit outcomes are similarly related to those at the course or grade level and to those at the program level. Program outcomes are such that they

contribute to the development of the core outcomes or goals. Note that the level of specificity increases toward the lesson and unit outcomes, and decreases toward the program and core outcomes and goals. As teachers work to develop curricula that include philosophical inquiry or aesthetics, they need to demonstrate how general outcomes in aesthetics and their more specific lesson and activity outcomes are encompassed by the more general outcomes or goals at the district, state, or national level.

Horizontal Alignment

Horizontal alignment refers to the configuration in which learning outcomes, strategies for teaching and learning, and strategies for assessment of learning are put forward. Horizontal alignment can be considered at any point in the vertical alignment configuration. For example, program outcomes can be configured horizontally, listing them with the ways in which they will be learned and taught and the ways in which they will be assessed. Assessment of programs in art typically is conducted periodically at the school or district level. However, consideration of horizontal alignment is particularly useful for teachers working at the unit or lesson level, because in attending to it, both they and students can routinely determine the extent to which unit or lesson outcomes are being taught and learned.

Horizontal alignment implies that instructional activities ought to be planned in a unit or lesson so that students will learn what they are intended to learn, and that assessment activities ought to be planned so that students and teachers can determine the extent to which learning has taken place. This seems simple enough, but in many cases, units and lessons get planned with outcomes that are never addressed in teaching, learning, and assessment activities. Further, assessment strategies are sometimes planned when it is difficult to see how they could possibly assess what was stated in the learning outcome.

Below is an example of horizontal alignment for a lesson in which students are engaged in philosophical inquiry. Note that the aesthetics outcome is repeated from the previous example of vertical alignment.

Lesson Outcomes	Instructional Activities	Assessment Strategies
The students will identify assumptions in various statements about art as they relate to the philosophical perspective of Expressionism.	Analyze quotes, identify assumptions with worksheets. Discussion about works of art in which students note peer comments based on Expressionism.	Review worksheets. Note student ability during discussions.

Assessment

Most of the work of assessment rests with the identification of learning outcomes. If we decide that it is important for a student to learn a particular concept or skill, then it is clearly important to determine the extent to which the student has learned it.

Many of the activities suggested in this book can be used to assess the extent to which students have learned those concepts or skills. Embedded assessment refers to assessment strategies included as an integral part of the lesson. Students take part in activities designed to help them learn a concept or skill, and these same activities will provide data for the teacher (and students) to determine the extent to which students have, indeed, learned what was intended. Assessment planned as an integral part of a lesson will help both teachers and students identify work that needs to be accomplished in subsequent lessons and activities.

If students are participating in a discussion, teachers can observe the discussion and take note of student abilities. Some teachers use a checklist, listing the names of the students and the skills to be addressed and noting when students successfully (or unsuccessfully) identify assumptions, make general statements, ask clarifying questions, and so on. Just as worksheets and other forms of writing can be used to introduce or practice certain skills, they can also be used for assessment of learning. Student journals or idea books can be collected and analyzed to determine the extent to which students are reflective about their experiences with art and are providing reasons for their positions regarding certain philosophical questions.

 On Mind-Changing

"Of course, an unchanged mind is a little like unchanged underwear. It tends to get unattractive even to the person whose mind or underwear it is."[3]
—Daniel Pinkwater, 1989

"Anyone who doesn't change his mind doesn't have one."[4]
—Peter Schjeldahl, critic for the *Village Voice*, 1993

General Outcomes in Aesthetics

The kinds of things that students should learn from their participation in philosophical inquiry have been alluded to in previous chapters. In what follows, learning outcomes are stated in general terms, indicating what might be included as outcomes at the K–12 program level. They are presented here in the form of broad concepts, skills, and attitudes and habits to be learned.[6]

1 Broad concepts

Generally, students will learn that:

- people tend to wonder and ask questions about art and beauty, their experiences with art and beauty, and the role of art in society.
- people develop beliefs and sometimes complex explanations or theories about art and beauty, their experiences with art and beauty, and the role of art in society. Beliefs about art and beauty are influenced by the values of a community or culture and may change over time.

A Director's Dilemma

As part of their final examination, high-school art students were asked to consider a question facing museum directors.[5]

Should art museums have exhibits that attract a lot of people but risk losing the respect of a smaller number of people who have extensive education in the arts, or display art for the serious patrons and risk a decrease in attendance? The students were told that because museum directors are increasingly judged by their ability to raise funds and because fund-raising is ultimately related to museum attendance, this question is particularly relevant. They were reminded that the local museum had recently scheduled an exhibit of cartoons to run during the annual River Festival, hoping to bring more people into the museum. Some of their responses follow:

"Exhibits like the cartoons spark interest, while the permanent collections promote longevity in appreciation . . . [T]he art museum was smart to have an exhibit which appeals to the whole family. Good exhibits might be left up twice as long as simple "cartoon" type exhibits; thus, people who attended the understandable exhibits would have twice as long to learn to appreciate the true 'art.'"

—Janice

"The only real solution is to try to find a happy middle ground between serious 'quality' work and simple exhibits with mass appeal. In order for the most people to be attracted, the museum must offer something to each of them. The integrity of the museum lies in its ability to provide a forum for serious artworks, but such a thing is not possible without adequate funding. One must put up with lower-level work in order to have the opportunity to experience the more serious exhibitions."

—James

"I think the answer to this dilemma, like so many others, needs to be found in the grays. We can't water down our museums with trash, although keeping them snooty, solemn, highbrow, elite . . . places simply aids (some people) in believing themselves to be in a caste above anyone else."

—Jason

- careful use of words, statements, and reasons can help people reflect, talk, and write about their questions and beliefs.
- careful reflection can result in a refining of and sometimes a change in beliefs.
- philosophers explore questions about art and beauty, about human experiences with art and beauty, and about the role of art in society; they construct explanations, or theories, to address these questions.

2 Skills

Generally, students will learn how to:

- reflect on their beliefs about art and beauty, their experiences with art and beauty, and the role of art in society.
- listen carefully to the point of view of others.
- carefully select and evaluate the use of words, statements, and definitions to make general statements about art and beauty, their experiences with art and beauty, and the role of art in society.
- identify and raise philosophical questions.
- carefully present reasons to support their positions.
- carefully analyze the positions of others.
- use the above skills to engage productively in philosophical inquiry alone or with others.

3 Attitudes and habits

Generally, given knowledge and skills such as listed above, students will be inclined to:

- wonder about art and beauty, their experiences with art and beauty, and the role of art in society.
- reflect on their own beliefs and reasons for holding these beliefs.
- offer and assess reasons for views offered with respect to aesthetic issues.
- seek and seriously consider alternative views about philosophical issues.

To draw from these general outcomes to formulate specific objectives for integration with sequential units and lessons of study, teachers should consider developmental capabilities of the learners; their prior knowledge of, experiences with, and questions about art; and what parts of the whole might logically follow others.

What is also important to recognize is that students can be made aware of concepts and skills; formally introduced to concepts and skills; provided opportunities to refine their understanding of concepts and skills; and provided opportunities to demonstrate proficiency in their knowledge of concepts and skills. This suggests that the same concepts and skills be addressed more than once throughout the K–12 art program, but done so in different ways, depending on the extent to which the students have developed or refined their understanding. Listening skills, for example, probably will be addressed throughout the art program, but students will no doubt demonstrate their ability to listen carefully in increasingly sophisticated ways, depending in part on what they are asked to listen to.

Specific Outcomes in Aesthetics

The K–12 program outcomes indicate what all students should know and be able to do as a result of their experiences in philosophical inquiry or aesthetics. Outcomes at the course, unit, and lesson levels are more specific because they indicate what students should know and be able to do as a result of addressing aesthetics in the particular grade level, unit, or lesson. Unit and lesson themes or content will vary, and specific outcomes will reflect both the specific concepts or skills to be addressed in the unit or lesson and the particular focus of the unit or lesson.

For instance, if the lesson included a great debate about whether a natural object such as a dried tree root should be included as part of an art museum's collection, one of the specific outcomes might read: Students will demonstrate that they know how to state their views concerning whether a natural object should be included in the collection of an art museum by taking a position and providing at least three reasons for the position taken.

A teacher should be able to explain how this specific lesson outcome is aligned vertically with the more general outcomes at the unit and program levels. This specific lesson outcome also can be shown to be aligned horizontally with instructional and embedded assessment strategies.

Age Appropriateness

Students in grades K–12 can take part in philosophical inquiry. Not only do young children have questions about art and their experiences with it, but they also can practice good thinking skills as they consider their beliefs and those of others. Thinking-skill programs exist for preschoolers in which they learn how to listen

carefully and state their beliefs with precision.[7] Young students, as well as middle and secondary students, can practice making general statements, making distinctions, comparing, classifying, analyzing, evaluating, representing ideas verbally and in written form, and making inferences. The questions they have and the complexity of their views will vary, depending on their experiences with art, with critical thinking, and in the world.

It is conceivable, then, that a nine-year-old student who has had rich and layered experiences in making and responding to art might have a far more sophisticated developing set of beliefs about art than an eighteen-year-old student who has just begun to think critically about art and its complexities. By the same token, it is conceivable that a six-year-old might have more sophisticated views than a nine-year-old.

A K–12 art program that provides all students with opportunities to reflect on philosophical issues and helps them practice and refine their thinking skills assumes that students in the upper grades will have more comprehensive sets of beliefs and will be better able to articulate their reasons for holding them. The key is to sequence learning in K–12 programs in aesthetics by providing topics for consideration that are increasingly complex, drawing on an increasing understanding of art; and by providing opportunities to practice and refine skills that are increasingly demanding.

Lesson Planning

As mentioned earlier, a useful way to begin to incorporate aesthetics into the curriculum is to examine units and lessons in an existing program and identify topics that lend themselves to philosophical inquiry.

Initially, aesthetics lessons planned in this way will probably have aesthetics as a secondary, rather than a primary, focus. Outcomes having to do with art-making, art criticism, or art-historical inquiry probably will be the primary focus for the majority of lessons. As teachers become accustomed to involving students in philosophical inquiry and designing activities to meet skills objectives, they may opt to create lessons or units that include aesthetics as the primary focus. In a balanced art program, the focus of units and lessons shifts among inquiry about meanings in works of art, inquiry about the social and historical origins and traditions associated with art, inquiry about the making of art, and inquiry about philosophical ideas, issues, and topics associated with art. Ideally, inquiry in these areas is interwoven. As suggested in Chapter 4, philosophical issues are embedded in inquiry in the other areas of the art curriculum, so the infusion of activities for their discussion follows with little disruption or notice. It is prudent to periodically distinguish among the various kinds of inquiry and focus on concepts and skills associated with a particular area of inquiry. Students need to be aware of the types of questions they raise and the specific strategies and skills required to address them so that they can incorporate this learning into lifelong habits of inquiry. Units and lessons are thus developed in which particular areas of inquiry are the primary focus. Other areas of inquiry might then have a secondary focus. Samples of lessons in which aesthetics is a primary or secondary focus are included below.

Sample Lessons

Can any pictures made by computers be called *art*? What is your opinion? Give reasons to support your ideas.

(See page 120 for complete worksheet.)

Lesson Title: Regionalist Art[9]
Level: Fourth grade
Type: Aesthetics as secondary focus
Questions and issues prompted by consideration of a particular art form (computer-generated imagery)

Context and Overview

This lesson is part of a unit on American Regionalist art, in which the art teacher showed his fourth-grade students the works of Grant Wood, Thomas Hart Benton, and other artists of their period. The students have addressed art criticism, describing and interpreting various works. They have learned about the era in which these artists were making art and about how artists can play a role in expressing ideas and feelings about their world. In previous units of

 Responses to Worksheet
(grade 4 students)[a]

"No, I think that art should be drawn by hand. Real art is made by the human, not the machine. Also, if it's made to look so real, it can't be art . . . To me, art can be sculpted, painted, sketched—anything as long as it isn't made by something that is told to do it. Real art is made by inspiration."
—Sarah

"I consider pictures like the one above art because art is an expression in your mind put some way for other people to see. So if this is an expression from someone's mind, it has to be art. Not all pictures made by a computer can be called art. Some pictures made by computer aren't someone's expression and are not [part of] imagination."
—Kim

"Yes and no. Pictures like the one above are not art. They are only copies of the real picture; therefore, they are copies of art. The original picture designed on a computer by an artist is art because it is something 'new' designed by a human using a computer as a tool."
—Leslie

"I think that computer-generated images can be called art because books are written on computers and they are considered a type of art. Also, I think that art is something that you create. If you draw or paint, or by some means create a picture on a computer, it is art. I don't, however, consider 'clip art' art. Well, not your art, anyway. If someone drew it and then made it possible for you to reproduce it on a computer, then it is art, just not yours."
—Kathryn

"I think that art made on the computer is sort of artwork. When I make pictures on the computer, I think of them as just things I did for fun. Some people may call it artwork, but I don't. You can't draw as well with a mouse as with your own hands. I don't think anything made on the computer will be classified as art this century."
—Keri

7.1 Honda Odyssey advertisement. *Based on a design by Keith Haring. Computer graphic. Courtesy of the Estate of Keith Haring, American Honda Motor Company, Inc., and Rubin Postaer and Associates.*

study, the teacher asked these students to think about art in general terms, and they have begun to develop their own definitions of art. Toward the end of the unit, the students took part in a discussion about computers and art. On a worksheet prepared for their comments, the students wrote their views about whether a computer-generated image of Grant Wood's *American Gothic* should be considered art. They also explained whether they think all pictures made by computers are art.

Aesthetics Outcomes

• The students will learn that our beliefs about and definitions of art can be tested or challenged by new forms of expression and technological developments.

• The students will learn how to state their views concerning a particular philosophical issue and their reasons for holding these views.

Instructional Strategies

1 Students participate in a large-group discussion in which they address the question "Can a machine make art?"
2 Students complete a worksheet that asks them whether a computer-generated image of Grant Wood's *American Gothic* can be considered art.

Assessment Strategies

By examining the completed worksheets, the teacher will determine the extent to which the students demonstrate skill in stating their view and providing reasons. (A scale or rubric can be created to identify levels of achievement for this particular skill.)

Lesson Title: Keith Haring in the News
Level: Middle-school grades
Type: Aesthetics as primary focus
Questions and issues prompted by newspaper article

Context and Overview

Prior to this lesson, students learn about the life and work of Keith Haring, studying images, reading, hearing stories, and watching a videotape. They compare his ways of working to those of other artists in our culture and in other cultures.

In this lesson, the students are told about an article in the *New York Times* with the headline "An auto maker uses a cult artist's colorful images to make its mini-vans stand out from the pack."[10] The article reports that in an advertising campaign for their new mini-vans, Honda is using images created by the artist Keith Haring. Honda received permission and even suggestions from the artist's estate to use the images. Honda has incorporated Haring's "colorful, genderless people" into their ads, commercials, and billboards. Some of his characters have been animated in the commercials. According to the article,

Honda hopes that by using the Haring images, people will think that mini-vans are "hip," rather than unexciting vehicles for suburban families. For commercial purposes, the Haring images were taken out of their original contexts, and the Honda illustrators took license by adding to the originals. Keith Haring never drew a mini-van rear seat, for example. They also used the familiar baby image—a crawling baby surrounded by Mr. Haring's "bright marks"—and replaced the baby with a mini-van.

Aesthetics Outcomes

- Students will learn that individual and social values influence the ways in which art is used and appreciated.
- Students will learn how to carefully present and evaluate reasons in support of their positions and the positions of others.
- Students will learn how to identify factors to consider before taking a position about an issue.

Instructional Strategies

1 Students are divided into groups to identify at least two important factors to consider when addressing the question "Should Keith Haring's images be used to sell Honda mini-vans? Why or why not?" Answers are shared with the entire class and recorded in a place visible to all students.

2 Working within their groups and assuming various roles (Keith Haring, Honda CEO, collector of the work of Keith Haring, Keith Haring family member, art historian, Honda salesperson, mini-van consumer, art critic, art student), the students take part in a dialogue in which they address the question, attending to the factors identified by the class. Each group is given a handout with one or more of the following questions to consider:

- Are viewers of these advertisements and commercials viewing the work of Keith Haring? Why or why not?
- If parts of Haring's artworks are used in advertisements, should these be considered his work?
- Haring's work was most often two-dimensional and static. When his images are animated for television commercials, are they still his images?
- Would the situation be different if the artist were alive? How so?
- Will the response of viewers seeing his work in the context of the Honda ad be different from their responses to his work seen on museum walls? In what ways will their responses be similar? Different?
- Compare the use of Keith Haring's work and the *Mona Lisa* in advertisements. Is there a difference in using Haring's artistic style and/or parts of his artworks and using the *Mona Lisa* and other famous artworks to sell products?
- In what ways is the use of his imagery to sell mini-vans consistent with the meanings in and the uses to which Keith Haring put his artworks?
- In cultures worldwide and throughout history, artists have made things used for purposes linked to a culture's social practices. We live in a consumer society, one that emphasizes the buying and selling of products. Is the use of Haring's work to sell products in our society different from the use of a mask created by someone for ritual dances in another society?

3 After separate groups have discussed the questions, students who have played specific roles meet to discuss what transpired in their respective groups and how they played the particular role assigned to them.

4 Students write about the experience in their journal for thoughts about art. They address the following:

7.2 Cindy Sherman, Untitled #224, 1990. Color photograph, 54 x 44" (137 x 112 cm). Courtesy of the artist, Metro Pictures, and Linda Cathcart Gallery, Santa Monica, CA.

a. In the discussion, I assumed the role of_____ .

b. In order to play this role, I had to think about

_____ .

c. "People have different perspectives about art that reflect those things that are important to them." I agree/disagree with this statement because _____ .

Assessment Strategies

1 When groups convene to discuss the factors to consider before continuing the discussion, the teacher notes the extent to which the students are able to identify factors.

2 During the group discussions, the teacher observes the extent to which students are able to present and evaluate reasons in support of their positions and those of others.

3 The teacher reviews comments in the students' journals to determine the extent to which the students have learned that individual and social values influence the ways in which art is used and appreciated.

Other Activities

Students use parts of a reproduction of a known artwork to create a commercial message. They are to think about how the use of this image creates meaning in the work. What does it add? How was it changed? Is the image significant in the context of the message?

Students begin a collection of advertisements that incorporate known artworks or familiar artistic styles. They create a bulletin board of these advertisements for the school community. They might include a question for the school community to consider. (Whose art is it? Does the meaning of an artwork change when placed in an unintended context?)

Lesson Title: Truth and Photographs
Level: High-school grades
Type: Aesthetics as a primary focus
Questions and issues prompted by consideration of artworks, news events, and a particular art form

Context and Overview

This lesson is one within a unit on photography. Throughout the unit, students are involved in art-historical inquiry, noting the origins and some of the earliest examples of photography and the social and cultural contexts in which they were made. They consider specific photographers—historical and contemporary—and take part in art-criticism activities. They refine their art-making skills using photographic methods.

In this lesson, students explore the art form of photography and its relationship to truth. Photographs are generally accepted as presenting to the viewer an accurate depiction of something in the world. By looking carefully at photographs and the contexts in which they were taken and are presented, students are challenged to alter their assumptions and offer definitions of the art form.

Aesthetics Outcomes

- The students will learn that definitions of important art terms or art forms can change as a result of social, cultural, and technological developments.
- The students will learn that individuals have different definitions and theoretical positions about key art concepts.
- The students will learn how to identify assumptions in statements made about photography.
- The students will learn how to carefully present and justify a position.

 Consider This

- The *Christian Science Monitor* has used computer technology to "remove" cigarettes from the hands of people in photographs, and has even removed the cigar from Winston Churchill, who was known for his cigar smoking.

- Using computer technology, a *TV Guide* cover showed a photograph of Oprah Winfrey's head on the body of Ann-Margret. Neither celebrity was informed beforehand. Nowhere in the magazine was there any indication that the photograph was a hoax.

- In 1982, *National Geographic* "moved" two pyramids closer together to improve the way the image looked as a magazine cover.

- A photo finish is one in which the contestants in a horse or automobile race are so close that the winner is determined by examining a photograph of them crossing the finish line.

- Lewis Hine was a photographer who documented deplorable conditions in factories. His photographs aroused citizens to call for changes in the law so that workers would be protected.

- Tourists often take photographs of themselves in front of special places, presumably to show that they were actually there.

- Cindy Sherman disguises herself in costumes and makeup, then shoots the photograph.

- William Wegman poses his dogs, sometimes in costumes, and photographs them, often doing "human" things.

About Photography

"I really believe that there are things nobody would see if I didn't photograph them."[11]
—Diane Arbus, photographer

"Instead of just recording reality, photographs have become the norm for the way things appear to us, thereby changing the very idea of reality and of realism."
—Susan Sontag, critic and theorist

"To say that it [photography] has changed the way we view the world and ourselves is perhaps an understatement; photography has transformed our essential understanding of reality and, in the process, transformed itself. No longer are photographic images regarded as innocent 'mirrors with a memory,' merely reflecting the world back at us in a simple, one-to-one translation. Rather, they construct the world for us, helping us to create the comforting illusions by which we live."[12]
—Andy Grundberg, photography critic

"It is one of the peculiar characteristics of the photograph that it isolates single moments in time."
—Marshall McLuhan, theorist

- The students will learn how to raise philosophical questions that pertain to the art form of photography.

Instructional Strategies

1 Each student brings in two photographs—one that the student believes shows the truth and one that does not show the truth. Working in pairs, students interview each other about their choices. Each pair chooses two photographs to be placed appropriately on a bulletin board under the headings "Photographs Tell the Truth" and "Photographs Falsify the Truth." In a large-group discussion, students take turns explaining and justifying their decisions. The other students agree or disagree, and provide reasons for their positions. As the unit continues, the students add other photographs to the bulletin board and have similar class discussions.

2 Working in small groups, the students identify at least five philosophical questions related to photography for the class to discuss. The philosophical questions are listed under the heading "Big Questions about Photography" in a place visible to all students. Students continue to add to the list.

To help the students raise philosophical questions, they are given several handouts with statements about photography by photographers, critics, historians, or others; descriptions of real-life situations or events; and photographic images created by various artists.

7.3 Lewis Hine, Child Victim of Accident in Mill, 1909. Gelatin silver print, 5 x 3" (12.4 x 7.8 cm). Courtesy George Eastman House, Rochester, NY.

3 Students have large- or small-group discussions about specific questions they have raised and listed.

4 Students use the following prompts to write in their journal for thoughts about art.
 a. Imagine that you have been asked to explain what photographs are to someone who has not had much experience in viewing and/or thinking about them. What would you say to this person?
 b. Find two statements that make different assumptions about photography. How are these positions different? Do they have any similarities? Which position is closer to what you believe? Why?

Assessment Strategies

1 As students classify photographs into certain categories, the teacher observes and notes the way in which they present and the extent to which they justify their positions.

2 As students identify philosophical questions related to photography, the teacher notes the extent to which students are able to identify philosophical issues. The teacher also notes the extent to which students can distinguish philosophical questions from other sorts of questions.

3 The teacher reviews journal entries to determine how well the students understand the impact of social and technological developments on definitions of photography.

4 The teacher reviews journal entries to determine the extent to which students are able to identify underlying assumptions.

5 The teacher reviews journal entries to determine the extent to which students are able to identify two different views on the subject of photography.

Unit Overviews

The following overviews suggest additional ways in which aesthetics can be incorporated into the art curriculum at the high-school, middle-school, and elementary-school levels. Note that these are not fully developed plans. With one exception, specific outcomes are not provided and assessment strategies are not included in any of the overviews. They do indicate varying levels of sophistication, however. The high-school unit extends over several months and draws upon a sophisticated understanding of art and art institutions. The middle-school interdisciplinary unit requires that students link their understanding of art to concerns of the community. In addition, students are challenged to examine their previous assumptions about specific art concepts. The elementary unit overview suggests how younger students can begin to consider the relationship of form to function and how this relationship also reflects the needs and interests of different people.

Lesson Title: Curating an Exhibition[13]
Level: High-school grades
Type: Aesthetics as a secondary focus prompted by considering institutions involved with art

Context and Overview

Students in an advanced art class participate in a unit of study in which they curate an exhibition of student art from local high schools. The exhibit is to be held at the community's arts center. Students write a proposal for the exhibition and present it to the board of trustees. Students determine the theme and scope of the exhibition, create announcements and a call for entries to be distributed to the local high schools, determine criteria for selection, jury the exhibition, create publicity, raise funds and get

sponsors for the show, write a catalog, "hang" the show, plan an opening reception, and take part in a panel discussion of the process.

To be involved in the work of curating the exhibition, the students explore the role of arts centers, museums, and similar institutions in a community. Their views on this relationship have an impact on how they present the exhibition to the board and what criteria they establish for selecting works to be shown. In reflecting on the process, they consider how it is similar to and different from other activities in which they participate as students of art.

Aesthetics Outcomes
- The students will learn that individual and social values influence the ways in which art is used and appreciated, particularly in art institutions.
- The students will learn how to carefully present and evaluate reasons in support of their positions.
- The students will learn that the context in which an artwork is presented influences the way it is perceived and understood.

Instructional Strategies
1 Students consider a statement by Philippe de Montebello, director of the Metropolitan Museum of Art.

We believe in rankings and hierarchies—and the notion that some things are better and more beautifully designed than others. And that the fundamental purpose of a museum is to teach that point—there's such a thing as quality. . . If one caves in too much on the many demands of making things accessible in the wrong way, such as popularization, rather than simply making things accessible on every level, I think one is cheapening the currency . . . Art is not easy. And we shouldn't work hard at trying to cheapen the experience.[14]

- What does the writer believe to be the role of a museum in society?
- How do you think the writer would comment on the criteria established for selection of works for the exhibition?

2 Students create several models for displaying the selected works. For each model, they determine what message is communicated by the way in which the work is displayed. They must decide on the best plan on the basis of the message it communicates.

3 Students reflect in their journal on the process of planning an exhibition, comparing it to making a work of art.

Lesson Title: Monumental Undertaking: Testing Definitions[15]
Level: Middle-school grades

Context and Overview
In an interdisciplinary unit in which they investigate the question "How do societies change?," students explore the significance of monuments to societies. Students think of examples of monuments with which they are familiar. They then list characteristics of monuments and construct a definition. Students take photographs of monuments and keep a photo log in which they record information about the monument, their responses to it, and the responses of others. They photograph at least one monument per week for several weeks. Students are given a different assignment each week. For example, for the first week, students photograph the monument closest to their home. In subsequent weeks, they photograph monuments that are in unusual or unexpected forms, that are in small scale, that are in what they believe to be good sites, that are monuments to American culture, and so on. Students bring in magazine pho-

tographs or examples of monuments to be displayed on a "monument wall" with the headings "Definitely Monuments," "Definitely Not Monuments," and "Maybe Monuments." As examples are brought to class, discussions are held to determine under which heading they will be placed. These examples, in addition to student experiences in completing their photo logs, function to "test" the definition that students have constructed. Students alter the definition to reflect any changes in their thinking.

Students consider such questions as "What is the difference between a monument and a shrine?," "In what ways might a department-store window display be considered a shrine? A monument?," and "In what ways might a desk or dresser top be considered a shrine? A monument?"

Students look at works by Constantin Brancusi, Andy Goldsworthy, Amalia Mesa-Bains, Maya Lin, Michelangelo, Claes Oldenburg, and others, and consider if and in what ways the works might be considered monuments.

Throughout the unit, students consider how societies have responded to change. Each student chooses a particular society and conducts research about the ways in which that society has adapted to changing conditions or crises. In a culminating activity, the students create models for monuments that could be placed in those societies.

Lesson Title: Objects and People
Level: Elementary-school grades

Context and Overview

In this lesson, students investigate the form and significance of objects to the people who use or have used them. Students bring in an ordinary object from their home, perhaps something from a kitchen drawer or toolbox. They work in pairs to carefully observe the form of the object, the materials of which it is

7.4 Chris Mitchell, grade 7, Helping Hands, 1997. Tagboard, plasticene, candle, sterno, photocopied images. 6 3/4 x 11 3/4" (17 x 30 cm). Model for a proposed monument to the rescuers and victims of the Chernobyl nuclear accident. Photo: Suzy Becker.

made, and any special features such as decoration. They might also make drawings. They interview family members and/or do research to discover how the object is used and its significance to the people who use or have used it. Students research to discover what kinds of objects are used in other cultures to perform functions similar to those performed by their object. Working together, they create an exhibit of their collected objects. They must determine how they will organize the objects and what kind of information they will include on exhibition labels.

In discussions or on worksheets, students are asked to consider the following:

1 Are ordinary objects important? Why or why not? Are some objects more important than others?

2 Why do you think certain objects are important to some people and not to others?

3 Why do ordinary objects look the way they look?

4 Should ordinary objects be decorated? Why or why not?

5 Why is it that some objects used for the same purposes look different from each other?

The general outcomes in this chapter encapsulate what the entire text puts forward about the rationale and ideas related to involving students in philosophical inquiry. We can consider these outcomes in light of the more general goals of schooling and the broad arts and humanities outcomes at the state or district level. General outcomes can be broken down into specific outcomes to be included at the program, course, unit, and lesson levels. As aesthetics outcomes are made more specific, they can provide direction for the development of instructional and assessment strategies. In designing these strategies and developing curricula, teachers can adapt the many suggestions in this book and thereby incorporate aesthetics as an integral and viable component in the artroom.

Notes

1 High school art student journal entry, Wichita East High School, Wichita, KS; Brenda Jones, art teacher.

2 These outcomes are not those of any specific state, region, or district.

3 Daniel Pinkwater, *Fishwhistle: Commentaries, Uncommontaries, and Vulgar Excesses* (Reading, MA: Addison-Wesley, 1989) 172.

4 Peter Schjeldahl, quoted in Barbara MacAdam et al., "Anyone Who Doesn't Change His Mind Doesn't Have One," *ARTnews* 92: no. 9 (November 1993) 144.

5 High school art students, Wichita East High School, Wichita, KS; Brenda Jones, art teacher.

6 These general outcomes are adapted from Marilyn G. Stewart, "Aesthetics and the Art Curriculum," *The Journal of Aesthetic Education* 28, no. 3 (Fall 1994); reprinted in Ronald Moore, ed., *Aesthetics for Young People*, (Reston, VA: The National Art Education Association, 1995) 77–88.

7 See Janet Kruse and Barbara Z. Presseisen, *A Catalog of Programs for Teaching Thinking* (Philadelphia: Research for Better Schools, 1987) for concise summaries of some of the major commercial published programs that teach thinking. The catalog is organized by programs for specific age groups and includes programs that focus on pre-school age children through adults.

8 Fourth grade student responses, Oley Valley Elementary School, Oley, PA; Jeffrey Dietrich, art teacher.

9 This lesson is adapted from one taught by Jeffrey Dietrich, art teacher, Oley Valley Elementary School, Oley, PA.

10 James Bennet, "An Auto Maker Uses a Cult Artist's Colorful Images to Make Its Mini-Vans Stand out from the Pack," *New York Times*, 19 January 1995, sec. C, p. 17.

11 Unless otherwise noted, the remaining quotations in this chapter are cited from one of the following references: Jonathon Green, *Morrow's International Dictionary of Contemporary Quotations*. (New York: William Morrow and Company, Inc., 1982); and Rosalie Maggio, *The Beacon Book of Quotations by Women* (Boston: Beacon Press, 1992).

12 Andy Grundberg, "Now, the Camera's Eye Turns Inward," *New York Times*, 28 May 1989, sec. 2, p. 1.

13 This unit of study is adapted from one implemented by Brenda Jones, art teacher, Wichita East High School, Wichita, KS.

14 Robin Cembalest, "The Persistence of Philippe de Montebello," *ARTnews*, December 1993, 109.

15 The monument unit is adapted from a unit of study designed by Suzy Becker, art teacher, and other faculty at the Parker School, Devens, MA.

Appendix

Note to teachers: Worksheets and Activities in this Appendix are designed for you to copy and use in your classroom. For best results, you may want to enlarge them when copying and block off any teacher Instructions at the bottom of the page.

Philosophical Questions

Divided into questions about artworks, art-makers, responders, and contexts, these philosophical questions show the range of issues that might be raised about art and our experiences with it. Teachers can review this list as they plan aesthetics activities or explore topics related to lessons. Students can review the list for issues of interest to them. The list is not complete; questions may be added as they emerge from regular involvement in philosophical inquiry.

About Artworks

Definitions of Art

- In what ways are artworks special? What makes some artworks better (or more special) than others?
- What purposes do artworks serve? What is art for? Who uses art?
- Does art mean the same thing in every culture? In every group? Does art mean the same to adults as it does to children?
- Does every artwork have a purpose? Should every artwork have a purpose?
- What kinds of things would you say could never be an artwork?
- Are all artworks about something? Does every artwork tell a story of some sort?
- Can an artwork be *about* something and not show anything recognizable? For example, is a painting of only colors and shapes *about* something?
- In what ways do artworks tell the truth? Do all artworks tell the truth?
- If a painting shows an image of something that never happened, can it still tell the truth?
- Do artworks have to be beautiful or pretty?
- Can something that is ugly be considered art? Who decides what is ugly? Why will people some-times agree about what is ugly or what is not ugly?
- What makes an artwork good? Do standards for good art stay the same? Should they stay the same? Why will people sometimes agree about what is good art or what is not good art?
- If an artwork makes someone feel sad or bad, can it still be considered good? Why?
- Can an artwork help change the way people think or behave?

Types of Art

- What makes one kind of artwork different from another? In what ways, for example, is a painting different from a sculpture?
- Is it important to notice differences among different kinds of artworks? Why or why not?

About Art-Makers

- Why do people make things?
- Why do people decorate things—their home, yard, car, locker, notebooks, clothing, and body?
- When people decorate things, are they making art?
- What is an artist? Are artists the same in every culture? Do they have the same roles and responsibilities?
- What roles might an artist play in a culture? What might be the artist's responsibility to others in the culture? Who should decide this?
- Is anyone who enjoys making things an artist? Why or why not? Where do we get our standards for who is considered to be an artist?
- Is it a good thing to be an artist?
- Are there rules that art-makers should follow to make good artworks? If so, what are some of the rules?
- Do artists have to take a lot of time to make good artworks? Why or why not?

- Should artists always make something that has not already been made?
- Must an artist be a good or sincere person to make a good work of art?
- Can an artist make a good artwork with the intention of tricking or fooling the viewer?
- To tell us about the artist, do artworks have to be self-portraits?
- Is it possible for an artist to intend to express one idea in an artwork and actually succeed in expressing something else?
- What is it that people express through artworks they make?
- Do art-makers express their feelings? Their ideas? Their beliefs? Always? Sometimes?
- To express feelings in the artworks they make, do art-makers have to feel something?
- Is it ever acceptable for an art-maker to have an idea for a work of art, but have other people actually make the artwork? Would this always be acceptable?
- Is it ever acceptable for an artist to use a computer to make art? Why or why not?

About Responders

Art Criticism

- To interpret the meaning of an artwork, should the artist be consulted? Why or why not?
- Do artworks always have the meanings that the artist intended them to have?
- Are titles important clues to understanding the meaning of an artwork? Why or why not?
- When is it appropriate for an artist to title an artwork? Is it ever inappropriate? Under what conditions? Why?
- Do the meanings of artworks change over time? If so, how?

- Do the meanings of artworks change from one place to another? If so, how?
- Can we understand the meanings of artworks made in cultures other than our own? Is this always possible? Is this never possible? Do we need to have certain kinds of knowledge to understand art from other cultures?
- Can we understand the meanings of artworks made long ago? Is this always possible? Is this never possible?
- What makes some interpretations better than others?
- What does it mean to evaluate or judge an artwork?
- Is a judgment the same as an opinion? If not, how are they different? How are they similar?
- Is it possible to like an artwork, but judge it as not good?
- How do we know if an artwork is good?
- How important is it that everyone agree about the value of an artwork?
- Who decides what makes an artwork special, valuable, or good?
- Why is it that often, people in a culture will agree about what makes an artwork good or about what kind of art is important?
- Why is it that people in the same culture or time period do not agree about what kind of artworks are important?
- How do our beliefs about art influence the ways in which we perceive, interpret, and evaluate artworks?
- Where do people obtain their beliefs about art?
- How do a person's beliefs about what makes a good artwork influence what artworks she or he chooses to see or have?
- How do a person's beliefs influence the way she or he interprets the meaning or message in an artwork?

Experiences

- Is there a "best way" to respond to artworks? Should people respond to artworks by feeling something? Should people respond to artworks by thinking in new or certain ways?
- Is it okay to be uncomfortable with an artwork?
- Do some kinds of artworks prompt certain kinds of responses? How do you learn how to respond to artworks?
- Are there certain responses that are inappropriate? Is it okay, for example, to feel sadness, fear, or anger when you look at an artwork?
- Is the experience of looking at what you consider a good artwork similar to the experience of looking at a beautiful sunset? In what ways? How are these experiences different?

About Contexts

- Do artworks tell us about the world or culture in which they are made? How is this possible? To tell us something about the world or a culture, do artworks have to show the world the way it really looks? Why or why not?
- Are the activities of art-making and perceiving important in a society? Under what conditions would these activities be less or more important?
- Should we ever censor works of art? If so, under what conditions?
- Should we ever destroy an artwork? If so, under what conditions?
- Why are some kinds of objects made by people in a culture considered more important as artworks than others? Who decides?
- What kinds of artworks should be displayed in museums?
- What is the role of museums in a culture? Are they important?

- What is the role of art historians in a culture? Are they important?
- Should we keep artworks made in the past? Why?
- Should we keep in our museums artworks that were made by people in other cultures? Why?
- What is the purpose of art critics? Are they important? Why? Should anyone care what an art critic has to say about artworks?
- What can people learn from artworks made in their own time and place?
- Are artists important in a culture? Why?
- Should artists follow the same moral rules as everyone else?

Fallacies: Common Errors in Reasoning

Fallacies are arguments that sound good, initially. They tend to be persuasive, but their persuasiveness rests on faulty grounds. Fallacies might be deliberate or accidental. People who want to have reasonable dialogues need to be aware of these fallacies when presenting their position, and when considering the positions of others. The following types of fallacies are those that frequently occur in philosophical discussions with children.

Appeal to Ignorance

When trying to persuade others to accept a position, people will sometimes say that something must be accepted as true because there is no evidence that it is not true. On the other hand, people might say that something is *not* true because there is no evidence that it *is* true. An appeal to ignorance might serve to persuade, but an argument is much stronger if it rests on evidence, not ignorance of evidence.

Appeal to Authority

Referring to authorities sometimes makes a position stronger, but the authority must be one who is particularly knowledgeable in the area being discussed. In addition, she or he must not be prejudiced about the issue at hand.

Appeal to Pity

Appealing to the sympathies of others to persuade them to accept a particular position is faulty reasoning, especially when these appeals are the *only* reasons given to accept the position. Listeners might allow themselves to be emotionally touched by an argument, but need to consider additional good reasons in support of a conclusion or position.

Appeal to Force

Threats are sometimes made to get people to behave in certain ways, usually when other reasons have not been effective. Listeners should ask for good reasons to behave or act in certain ways and should avoid being moved to action *only* because a threat of some sort has been made.

Appeal to Popular Attitudes

When someone strives to make others accept a position *only* through appeals to high ideals, such as patriotism, their argument is fallacious. Such persuasive appeals can be effective, but for arguments to be acceptable, they must be accompanied by good reasons.

Hasty Generalization

Also known as "jumping to a conclusion," this fallacy occurs when someone draws a conclusion or makes a generalization from too few examples or instances of occurrence. Alternatively, this fallacy occurs when a conclusion or generalization is made on the basis of the *wrong kind* of examples—examples that are not typical or are not related to the generalization.

False Cause

As suggested by its name, this fallacy occurs when someone argues that one thing is the cause of something else just because it happened *before* the second thing. For something to be the cause of something else, more than a succession in time has to be argued.

Begging the Question

This occurs when someone simply restates in a conclusion what was stated in a premise of an argument. No new information is provided, even though the language used might be different.

Arguing against the Person

This reasoning error occurs when the claim of someone is rejected on the basis of real or alleged (and usually derogatory) information about her or him. The listener must consider the reasons offered and assume that an individual's association with certain ideas or behavior in the past, or with a group of people who assert certain ideas or prescribe certain behaviors, are not at issue. The focus should be on the reasons given to accept a particular position, not on the person providing the reasons.

Worksheet

Teacher Reflection Sheet

It is useful, especially as teachers begin to add philosophical inquiry into their curricula, to keep a record of these experiences. Such reflection can assist in future planning.

1 Philosophical Dialogue or Aesthetics Strategy

Date: _____

Class or group: _____

Question(s) or issue(s) discussed:

Class or group arrangement:

2 Good points:

3 Things to change:

4 Strategies that worked well and why:

5 Strategies that did not work and why:

6 Students who took an active part:

7 Students who did not take an active part:

8 More thoughts:

Worksheet

Thoughts About Art

This worksheet asks you to think again about ideas brought up in class. As you complete this worksheet for different class periods, your ideas might change. Think about some of the things that occurred to you during class discussions. Also think about some of the things that your classmates said and whether you agree or disagree with their ideas.

Today's date: _____

The activity or discussion question(s):

A statement made with which you agree:

Why you agree:

A statement made with which you disagree:

Why you disagree:

A statement made or question raised that you would like to think more about:

Question(s) that you still have about the topic:

Students can benefit from reflection about their experiences in philosophical inquiry. As entries are made over time, students can examine their thoughts about art, noting whether and how they have changed. They will also be able to note the questions that they have had along the way.

Worksheet

Forgeries and Art: Who Cares?

A *New York Times* article[1] reported that the Polaroid Corporation has introduced a replication service whereby "any two-dimensional image, a pastel, watercolor, oil painting, fresco, or tapestry can be reproduced in sizes up to 40 by 80 inches." A person who purchased a copy of a John Singleton Copley portrait painting said, "It's the luminosity of the fabric and the accuracy of the skin tone that have been captured so perfectly." Including expenses for a photographer to travel to the site to photograph the image, a copy might cost as much as $3,000.

- Which art-related issues might be raised about the Polaroid Corporation's replication service?

The French painter Jean Baptiste Camille Corot routinely signed the works of students and friends to help them financially. Modigliani also signed his students' paintings. When Picasso viewed known forgeries of his works, he often claimed that they were, indeed, his.[2]

- Are there ever circumstances under which you believe it is acceptable for an artist to sign an artwork made by someone else?

A wealthy family assumed that the painting *Portrait of a Lady* by Francesco Ubertini, was hanging in their home. When the J. Paul Getty Museum announced in 1967 that they had purchased the work from someone, the family discovered that two generations earlier, a destitute ancestor had made an exact copy of the painting before selling the original.[3]

- If you were a member of the family, how would you feel about the painting hanging in your home? Why?

The Metropolitan Museum of Art has among its collection a small Greek bronze horse, thought to be from the fifth century BC. After being on display for many years, the horse was declared a forgery in 1967. Five years later, it was declared as authentic.[8]

- When the bronze horse was declared a forgery, should it have been taken out of the collection? Explain.
- What is a forgery? Is it ever acceptable to make a forgery of a work of art? What is the difference between a forgery and a reproduction? Is it ever unacceptable to make a reproduction of a work of art?

Worksheet

What's in a Word?

An art teacher asked students to consider this:

The lyrics in many contemporary rock songs have been called obscene because they are sexually explicit and seem to approve of such things as violence, incest, torture, and mutilation. Do these kinds of lyrics pose a threat to conventional morality? Should they be censored? Are artists in a different category from others in society? Can artists say whatever they want to say?[4]

Below are some excerpts from student responses. After each response, indicate whether you agree or disagree with some or all of the response. Provide reasons for your position.[5]

"Art, be it rock lyrics, painting, or sculpture is a means by which the artist expresses his feelings or attitudes. If an artist decides to write a song with explicit lyrics, there is probably some reason for his actions. More often than not he is simply breaking moral conventions for the sake of breaking moral conventions and attracting attention with the ultimate goal of selling records. However, these people do serve a fairly important purpose. By intentionally going out and breaking moral conventions, they help society to define for themselves exactly where these conventions lie—and to question the validity of the conventions. If no one ever goes to the borders (or beyond them) how do we know where they are, or if they exist at all?

. . . Obscene lyrics do not undermine morality. If anything, they strengthen it. If you don't know what is immoral, how can you avoid it?

. . . And if a song does somehow shift a society's moral conventions, the old conventions were dead anyway. The art did not change society, but reflected a change that society made within itself."
—Jeremy

Do you agree or disagree with some or all of Jeremy's comments? Why?

"As a human being, one chooses to expose their beliefs to those with similar or often opposing values. An artist is the ultimate reflection of many of these beliefs; he is someone people can look to for guidance and understanding of the events that make up their world. Yet the artist, too, is only human, so his form of expression will not always satisfy the masses. In our culture it is rare if everyone walks away happy, so why is it that many look for that ubiquitous moral medium in art?

. . . Art is something that one must understand to fully appreciate, because of the truths it is based around. It is reasonable to say that the majority of the white upper-middle class is not going to understand the true pain associated with a rapper's rhyme about the ghetto.

. . . Art makes people uncomfortable because it makes them question humanity's morals as a whole. . . The arts are much too small a part of this huge society to blame them for our decadence, and it would be a true breach of freedom and life to suppress an artist, no matter what his motives."
—Ariella

Do you agree or disagree with some or all of Ariella's comments? Why?

What other thoughts do you have on this topic?

Worksheet

American Gothic

The picture on the right is a computer generated image based on Grant Wood's regionalist artwork *American Gothic*.[6] What part of the picture is Gothic in style?

Computers today are capable of making detailed images and designs. Some programs and techniques can produce images that are as realistic as photographs. Do you consider pictures like this one to be *art*?

Can any pictures made by computers be called *art*? What is your opinion? Give reasons to support your ideas.

Activity

The Courtroom Drama: Image Appropriation

When an artist appropriates an image, is it art?

Situation: In 1988, the artist John Baldessari used a movie still, unaltered, in a work entitled *Two Languages Begin*. The artist claims the work as his own.

Players: Defense lawyer, Prosecutor, Judge, Witnesses for both sides (to provide evidence as needed) (Each role can be played by a team of two or more students.)

Defense lawyer:

Prepare your defense. You may decide to defend *Two Languages Begin* on the grounds that originality is not a valid notion. Or, you may decide to focus on the idea that the work is original because the artist has moved it out of its context.

Research. Look for other examples. Use what the artist actually says about the work.

Call witnesses or provide evidence to support your case. Evidence can be artists' statements or other important artworks. You may want to get statements from a curator, an art historian, or an art critic.

Present your case.

Prosecutor:

Prepare your case. You may argue that this work is not art because it is not original. Find out what the people in the community hold to be important factors to consider when determining what is, or is not, art.

Call in appropriate witnesses. Provide evidence of past artworks that are examples of originality as a criterion for something to be called art.

Present your case.

Judge:

Make a ruling for the prosecution or the defense. Weigh all the evidence. Write a summary with support for your decision.

Activity

The Courtroom Drama: Gardens as Art

Using the courtroom format and the same roles, students explore the reasons for and against gardens being considered artworks. The students conduct research about gardens. They will find that some gardens are pictured in art history texts, but they are generally associated with large estates. Students will need to consider such things as "ordinary" flower or vegetable gardens, window boxes, water gardens, arboretums, and sculpture gardens, as well as the gardens pictured in art history texts. They will need to consider the uses of gardens, how people relate to gardens, and symbolism associated with gardens. To prepare their cases, students might consider gardens from Formalist, Expressionist, Imitationalist, and Contextualist perspectives.

The courtroom drama[7] is an example of a way in which students (or groups of students) can assume roles, consider issues, and prepare arguments for their positions. In this example, the students are provided with guidance in preparing for their roles. Suggestions for points of view and possible evidence are provided. Teachers who wish to use the courtroom drama model will need to select an issue, review the relevant factors, and suggest possible directions for the students to take as they prepare their arguments and testimony.

Activity

Beliefs about Art

The following are summaries of ways to think about artworks. These perspectives, or beliefs, are sometimes used by people as they make judgments about artworks.

Expressionist

Artworks are valuable, have merit, or are significant because they convey or evoke feelings or moods.

Instrumentalist

Artworks are valuable, have merit, or are significant because of what they do. They perform something thought to be an important function. An artwork might be persuasive in getting people to think or behave in certain ways.

Formalist

Artworks are valuable, have merit, or are significant because of the way they are arranged, or formed. The parts of the work fit together well so that when people see it, they respond in a positive way. The message of the artwork is far less significant than the arrangement of its parts.

Imitationalist

Artworks are valuable, have merit, or are significant because they show objects or situations in ways that they actually exist in the real world.

Institutionalist

Something is called an artwork because the artist intends for it to be an artwork. The artist places the work in a context in which people who work with art (curators, critics, art historians, and so on) will see it and treat it as art. This perspective does not indicate what standards should be used to judge a particular work as good, valuable, or significant.

These may be placed on separate cards and used in a variety of activities.

Activity

Looking for the Bottom Line: Analyzing Comments about Artworks

Using your "Beliefs about Art" handout and the assistance of a few classmates, try to determine the philosophical perspective that is used to make judgments (indicated by author's emphasis in italics) about the merit, value, or significance of the artworks discussed by the fifth-graders below:[8]

"The artist has shown an old deteriorated no trespassing sign that looks like it's paper. It has been partially covered with twigs and leaves. . . *I consider this a good artwork because it is of something you would see and not really pay attention to but when you take a picture of it, you admire it much more.*"
—Ted

"I think this photographer is showing something that has a unique quality. It is a torn and tattered sign that states there will be no trespassing, but old age is taking the better of it. I think this is a symbol of how there are so many things that we could clean up in this world, not only the trash and litter, but the hatred. *I think this is a good piece of artwork because it shows so much and questions so much.*"
—Shelley

"I think that this artist means that art can be anything. I think it shows that art can be anything in the way that David Haas has taken a picture of not people or landscape, but a picture of an ordinary piece of forgotten trash lying on the ground. In a way, the sign is not trash. . . *I like this picture a lot. I like it because I admire the creativity of someone just walking around hunting for a decent picture and then*

taking a picture of what seems like trash, and then turning it into a beautiful artwork just by using their creativity, taking a picture and calling it art."
—Caitlin

"I think the photographer shot this picture because it is something you see every day and to tell you that you can get arrested for trespassing on people's land without permission. *I think it is a good photograph because it tells the Pennsylvania laws for trespassing and if somebody would see this in an art show and said, 'Why would you take a picture of that?' maybe it would come to them that he is trying to state that trespassing is against the law . . .*"
—Jarad

"I have chosen the picture *Five Star General*. In the picture, there is a very large GMC truck parked in front of an Albright's Mill. I think the artwork is showing the immense, menacing size of trucks like that. In the way of being interesting, *I think this picture is not very good, but in the way of being a good picture, I think it is because the photographer took the picture at just the right angle.*"
—Brad

"The artist is showing a large truck with a mill in the background. It is also showing the comparison of people and trucks. . . *I think it is a good photo but if I had a choice I wouldn't take a picture of it, nor would I hang it up in my room. But the photographer makes it look so real like you are walking right up and standing in front of it.*"
—Shannon

Notes:

1 "The Instant Art of Capturing History," *New York Times*, 9 August 1990, sec. B, p. 5.

2 Neil Steinberg, "Strokes of Genius," *Games*, May 1988, 12–17.

3 Ibid.

4 Adapted from *Puzzles About Art: An Aesthetics Casebook*, by Margaret Battin, et al. (New York: St. Martin's Press, 1989) 150.

5 Created by Brenda Jones, art teacher, Wichita East High School, Wichita, KS.

6 Jeffrey Dietrich, art teacher, Oley Valley Elementary School, Oley, PA.

7 Created by Brenda Jones, art teacher, Wichita East High School, Wichita, KS.

8 Fifth grade student responses. Oley Valley Elementary School, Oley, PA; Jeffrey Dietrich, art teacher.

Additional Resources

Books

Anderson, R. L. *Calliope's Sisters: A Comparative Study of Philosophies of Art*. Englewood Cliffs, NJ: Prentice-Hall, Inc., 1990.

Brand, Peggy Z., and Carolyn Korsmeyer. *Feminism and Tradition in Aesthetics*. University Park: Penn State University Press, 1995.

Cahan, Susan, and Zoya Kocur, eds. *Contemporary Art and Multicultural Education*. New York: The New Museum of Contemporary Art with Routledge, 1996.

Battin, Margaret P., ed., et al. *Puzzles About Art: An Aesthetics Casebook*. New York: St. Martin's Press, 1989.

Bolton, Richard, ed. *Culture Wars: Documents from the Recent Controversies in the Arts*. City New Press, 1992.

Dickie, George, and Richard J. Sclafani, eds. *Aesthetics: A Critical Anthology*. New York: St. Martin's Press, 1977.

Eaton, Marcia Muelder. *Basic Issues in Aesthetics*. Belmont, CA: Wadsworth Publishing Co., 1988.

Danto, Arthur. *The Transfiguration of the Commonplace*. Cambridge: Harvard University Press, 1981.

Dissanyake, Ellen. *What is Art For?* Seattle: University of Washington Press, 1988.

Gablick, Suzi. *The Reenchantment of Art*. New York: Thames and Hudson, 1991.

Gaarder, Jostein. *Sophie's World: A Novel About the History of Philosophy*. Translated by Paulette Møller. New York: Berkley Books, 1997.

Heath, Jennifer. *Black Velvet: The Art we Love to Hate*. San Francisco: Pomegranate Artbooks, 1994.

Jordan, Sherrill, ed., et al. *Public Art, Public Controversy: The Tilted Arc on Trial*. New York: American Council for the Arts, 1985.

Lacy, Suzanne, ed. *Mapping the Terrain: New Genre Public Art*. Seattle: Bay Press, 1995.

Lankford, E. Louis. *Aesthetics: Issues and Inquiry*. Reston, VA: The National Art Education Association, 1992.

Lippman, Matthew, and Ann Margaret Sharp. *Philosophy in the Classroom*. Philadelphia: Temple University Press, 1980.

Maquet, Jacques. *The Aesthetic Experience: An

Anthropologist Looks at the Arts. New Haven: Yale University Press, 1986.

Moore, Ronald, ed. *Aesthetics for Young People*. Reston, VA: The National Art Education Association, 1995.

Neperud, Ronald, ed. *Context, Content and Community in Art Education*. New York: Teacher's College Press, 1995.

Osborne, Richard. *Philosophy for Beginners*. New York: Writers and Readers Publishing, Inc., 1992.

Paley, N. *Finding Art's Place*. New York: Routledge, 1995.

Parsons, Michael J. *How We Understand Art: A Cognitive Developmental Account of Aesthetic Experience*. New York: Cambridge University Press, 1987.

Parsons, Michael J., and H. Gene Blocker. *Aesthetics and Education*. Urbana: University of Illlinois Press, 1993.

Risatti, Howard. *Postmodern Perspectives: Issues in Contemporary Art*. Englewood Cliffs, NJ: Prentice-Hall, Inc., 1990.

Ross, Stephen David, ed. *Art and Its Significance: An Anthology of Aesthetic Theory*. Albany: State University of New York Press, 1984.

Senie, Harriet F., and Sally Webster, eds. *Critical Issues in Public Art: Content, Context, and Controversy*. New York: HarperCollins Publishers, 1992.

Smith, Ralph A., and Alan Simpson, eds. *Aesthetics and Art Education*. Urbana: University of Illinois Press, 1991.

Journal Articles

There are many articles on the teaching of aesthetics. An excellent annotated bibliography of articles (and books) on aesthetics and other topics related to discipline-based art education can be found on-line through the Getty Education Institute for the Arts Web site, ArtsEdNet (http://www.artednet.getty.edu/).

Curriculum Resources

While many curriculum resources include components that address aesthetics and philosophical inquiry, the resources listed below are designed primarily to promote such inquiry.

Token Response, designed by Mary Erickson and Eldon Katter, prompts discussions as a result of students reacting to works of art and consists of sets of reaction "tokens," activity sheets, and a teacher's guide. Available through CRIZMAC, P.O. Box 65928, Tucson, Arizona 85728-5928.

Philosophy and Art, designed by Mary Erickson and Eldon Katter, introduces students to Western philosophies of art and includes small reproductions, game cards, activity sheets, and a teacher's guide. Available through CRIZMAC, P.O. Box 65928, Tucson, Arizona 85728-5928.

QuestionArte, designed by Marilyn Stewart, promotes philosophical inquiry, along with inquiry in art criticism, art history, and art-making. It consists of a set of four posters and sixty cards containing hundreds of questions in English and Spanish, and a teacher's guide. Available through CRIZMAC, P.O. Box 65928, Tucson, Arizona 85728-5928.

Videotapes

Aesthetics is a videotape that shows students and teachers engaged in philosophical discussions. The teacher's guide contains lesson plans and video notes. One of the five videotapes in the series Art Education in Action, it is produced by the Getty Education Institute for the Arts.

World Wide Web Sites

ArtsEdNet (http://www.artsednet.getty.edu/)
This on-line service is provided by the Getty Education Institute for the Arts and contains information and resources related to a wide range of concerns of art educators, including entries on aesthetics. Images, lesson plans, and other curriculum resources are also included. It has a special search engine that links to other arts education sites on the Internet.

ArtsEdge
(http://www.artsedge.kennedy-center.org/)
A collaboration between the John F. Kennedy Center for the Performing Arts and the National Endowment for the Arts (with support from the U.S. Department of Education), this site contains lesson plans and other curriculum materials along with information about arts events, interviews with artists, and other artworld guests. It also contains a list of national and state standards for education in the arts.

Aesthetics Online (http://www.indiana.edu/~asanl)
This site is the electronic supplement to the American Society for Aesthetics (ASA) Newsletter. Of special note are the reading lists and suggestions for teaching designed for novices.

About the Author

Marilyn Stewart is Professor of Art Education and Chair of Related Arts at Kutztown University of Pennsylvania where she teaches courses in art criticism, aesthetics, and art education. Known for her ability to translate difficult art education concepts into practical, inquiry-based activities for the classroom, Stewart is General Editor of the *Art Education in Practice* series. She is a frequent keynote speaker at meetings and seminars around the United States and serves as a consultant in a variety of projects sponsored by the Getty Education Institute, The College Board, and the Milken Family Foundation. She directed the 1995 and 1996 Getty-sponsored Kutztown Seminar for Art Educators.

The National Art Education Association honored Stewart as the 1997 Eastern Higher Education Art Educator of the Year. In addition, she was chosen as the 1997–98 Visiting Scholar with the Getty Education Institute for the Arts.

Index

26-27
 realism and, 25-26
institutionalist theories, 24
instrumentalist theories, 23-24
interviews, conducting, 73-74

journal
 dialogue within, 37
 entries, 12, 39, 80
 thoughts about art and, 70-71

Katter, Eldon, 74
Kaye, Tony, 53
Komar, Vitaly, 49
Kuspit, Donald, 27

Leonardo da Vinci, 27
 Mona Lisa, 51
lesson planning, 100
 Curating an Exhibition, 107-108
 Keith Haring in the News,
 102-104
 Monumental Undertaking:
 Testing Definitions, 108-109
 Objects and People, 109-110
 Regionalist Art, 101-102
 Truth and Photographs, 105-107
 unit overviews, 107-110
 See also art curriculum; curri-
 culum, planning; planning
linguistic theories, 25
living art, 53

Melamid, Alex, 49
Michelangelo, 51
Mona Lisa (Leonardo da Vinci), 51
museums, role of, 65

object ranking, 72-73

philosophical inquiry, xiv
 age appropriateness of, 99-100
 art curriculum and, 14-15
 art history and, 48-52
 asking prior questions and, 81
 children and, 8-9
 clarifying issues, 81
 climate for, 34-36

dialogues for, 36-37
discussed, 1
identifying assumptions for,
 83-84
interdisciplinary work and, 74
student artworks, 74-75
See also art criticism
philosophical inquiry, getting
 clear about, 78-81
 art, statements about, 78-79
 identifying statements to
 discuss, 79
 raising questions and, 80-81
philosophical phobia, 8-9
philosophical pluralism, 28
philosophical writing, analyzing, 73
philosophy, 4
 defined, 2
Plagens, Peter, xiii, 5
planning
 activities and lesson outcomes, 42
 assessment of student learning,
 43
 class configuration, 41-42
 philosophical dialogues, 39-43
 presentation, 40-41
 questions, issues, topics, 39-40
 skills to practice during dialogue,
 42
 unit and lesson themes, 46-47
 See also art curriculum; curricu-
 lum, planning; lesson planning
Plato, 18, 25
polling about art, 49
psychoanalytic perspective, 26-27

questions
 about artwork, 3-4
 in the air, 71-72
 to ask, 81
 big-, chart, 39
 about context, 6-7
 dialogues and, 37-38
 of fact, 29
 general versus particular, 28
 of interpretation, 29-30
 about makers, 4-5
 metaphysical, 30-31

about perceivers, 6
planning, 39-40
of value, concept, 30-31
about viewing art, 6
ways-to-answer, 28

Raphael
 School of Athens, 50, 51
realism, 25-26
role-playing, 62-64
 dramatic, 69
 extended, 69
 forgetting roles in, 65
 hypothetical situation, 64-66
 in-out-maybe, 69-70
 real life debate, 66-67
 with two roles, 65-66

Safer, Morley, xiii
School of Athens (Raphael), 51
Serra, Richard
 Tilted Arc, 66
Sherman, Cindy, 104-105
student artworks, 74-75

teachers, philosophical inquiry
 and, xiv-xv
teaching, aesthetic theories and, 18
theory, defined, 18
thinking skills, 78
Tilted Arc (Serra), 66-67
 hearing, 67
Token Response game, 74
Twombly, Cy, xi, xiii

velvet paintings, some facts
 about, 20
vertical alignment, 94-96

Weitz, Morris, 25
words, use of, 88-89
Wood, Grant, 101-102, 120
Wrapped Reichstag (Christo and
 Jeanne-Claude), 3
writing, 74, 86

Yu, Cao, 21